BEGINNER'S GUIDE TO
NATURE
PHOTOGRAPHY

Cub Kahn

AMHERST MEDIA, INC. ■ BUFFALO, NY

This book is dedicated to Mike and Rob,
brothers and keepers,
with gratitude for all the ways you have enriched my life
and for sharing this journey.

Published by:
Amherst Media, Inc.
P.O. Box 586
Buffalo, N.Y. 14226
Fax: 716-874-4508
www.AmherstMedia.com

Publisher: Craig Alesse
Senior Editor/Production Manager: Michelle Perkins
Assistant Editor: Barbara A. Lynch-Johnt
Proofreading: Donna Longenecker

ISBN: 1-58428-090-5
Library of Congress Control Number: 2002103390
Printed in Korea.
10 9 8 7 6 5 4 3 2 1

Table of Contents

INTRODUCTION
The Magic and Mystery4

Part One—Gearing Up
1. CAMERAS AND LENSES6
 35mm Cameras6
 Alternatives to 35mm Cameras7
 Lenses9
 Camera Care12

2. PHOTO ACCESSORIES13
 Filters .13
 Tripods15
 Flash .17
 Battery Tips18

3. FILM .19
 Film Speed19
 Print Film or Slide Film?23
 Film Choices24

Part Two—Constructing Photos
4. EXPOSURE25
 Exposure Modes25
 Manually Setting Exposures26
 Easy Exposure Situations33
 Not-So-Easy Exposure Situations . .33

5. COMPOSITION37
 Clarify Your Message37
 Keep It Simple38
 Be Patient39
 Fill the Frame39
 Consider Verticals39
 Find Lines41
 Place Subjects Off-Center42
 Make the Best of Natural Light . . .43
 Try a Tripod44

6. FOCUSING45
 Autofocusing45
 Manual Focusing48

Part Three—Working with Nature
7. LANDSCAPE PHOTOGRAPHY50
 Frame the Scene50
 Pick the Right Lens51
 Place the Horizon51
 Strengthen the Foreground51
 Add a Human Element52
 Landscape Photo Tips52

8. CLOSE-UP PHOTOGRAPHY62
 Get Close!62
 Consider Macro Gear64
 Depth of Field65
 Square Up to Your Subjects66
 Use Flash67
 Customize Lighting71
 Flower Photo Tips72
 Other Close-up Subjects73

9. WILDLIFE PHOTOGRAPHY74
 Get to Know the Animals74
 Use Long Lenses75
 Photograph Where You Live77
 Photograph Early and Late77
 Be Patient78
 Feed Wildlife?78
 Wildlife Photo Tips79

Glossary .86
About the Author89
Index .90

INTRODUCTION

The Magic and the Mystery

This book is based on the premise that even if you are a complete beginner at nature photography, you are ultimately capable of consistently producing excellent nature photos in a variety of situations. If you enjoy nature photography with a 35mm SLR or point & shoot camera and would like to learn more in order to increase your enjoyment, this book is for you. Even though the focus here is on film photography, if you are exploring the fascinating frontier of digital photography, you will find plenty of relevant concepts and techniques in the chapters on exposure, composition, focusing, landscapes, close-ups and wildlife photography.

In sixteen years of teaching nature photography courses and workshops, I've heard countless students describe their unexpected photographic successes as magic, then describe their seemingly inexplicable photographic failures as a mystery! Over and over I've heard amateur photographers say, "I don't know why this didn't work." The complaint usually involved photographs of a beautiful landscape, a spectacular sunset, or a close encounter with a rarely seen wild animal. And the reason for the complaint usually was that the quality of the photo did not match the photographer's memory. In the photographer's memory, the sky was bluer, the clouds were redder, the bear's eyes were brighter, the bull elk was bigger and closer!

The mystery of photos that "didn't work" is very frustrating . . .

If, like most outdoor photographers, you've ever had this kind of experience, you know just what I mean. The mystery of photos that "didn't work" is very frustrating, especially when it happens repeatedly or in the case of once-in-a-lifetime photo opportunities.

By applying the simple techniques described in this book and then critically evaluating your photos, you can dispel much of this mystery. You can break through creative barriers, you can vastly improve your ability to reproduce on film what you see with your eyes, and with practice you can build confidence in your photographic skills. Good nature photography is all about understanding the capabilities of your camera and lenses, the characteristics of your film and the

basics of good exposure, composition and focusing.

While I am all for dispelling the mystery of photographic failures, I hope that you hold on to the magic of nature photography! Photographing nature is a wonderful antidote for the manifold stresses that impinge on us as we hurry through our 21st-century lives. Whether you are in a neighborhood park or in a million-acre wilderness area, the experience of being outdoors, taking your time, moving very slowly, and opening your senses to your surroundings can do wonders for your soul. At its best, nature photography is a peaceful, meditative, focused activity that reconnects you to the natural landscape and the wondrous profusion of life wherever you are. If you look closely enough at your immediate surroundings, and if you look far enough into the distance, you will see great photo opportunities. The magic of nature photography is always available; it is outside your window right now, if you simply pick up your camera and step outside. Enjoy!

CHAPTER ONE

Cameras and Lenses

⊲ 35MM CAMERAS

The most popular cameras for nature photography are those that use 35mm film. Each image produced on the film used by these cameras is approximately 35mm (about 1½") in length. The two basic varieties of 35mm cameras are point & shoot cameras and single-lens-reflex cameras, usually called SLRs.

SLRs. SLRs are the first choice of most intermediate and advanced nature photographers for a number of reasons. One of the most attractive features of SLRs is that the lenses are interchangeable; you can use dozens of different lenses that range from extreme wide angle to long telephoto.

Another strong point of an SLR is that the viewfinder allows you to look through the lens. The image you see as you compose the scene is a very close approximation (usually near 90%, depending on the camera model) of the actual image your film will "see."

Most SLRs allow for partial or complete manual control of exposure, as well as totally automatic exposure. The capability to set exposures manually gives you creative control over the appearance of your photos. Most SLRs also permit you

Today's sophisticated point & shoot cameras are excellent for photographing well-lit landscapes. (Yellowstone National Park, WY; August; point & shoot camera with 38–80mm zoom lens; Fujichrome Velvia film)

to either autofocus or manually focus the lenses.

The vast majority of photos in this book were made with SLRs. When other types of cameras were used, this fact is noted in the photo captions.

Point & Shoot Cameras. "Point & shoot" refers to 35mm cameras that are compact, automatic, and have built-in lenses. Point & shoot cameras are popular because they are usually less expensive, smaller, and lighter than SLRs. Point & shoot cameras autofocus, automatically set exposures, and have built-in flash. However, point & shoot cameras also have notable drawbacks:

1. The vast majority of point & shoots lack manual control of exposure; this is a major disadvantage if you shoot color slide film, which has little tolerance for exposure errors, or if you face difficult lighting situations.
2. Lenses are not interchangeable on point & shoots; you are limited to the lens that is built into the camera. Long telephoto lenses for wildlife photography are not available.
3. Close-up photography is hindered because point & shoots cannot focus on subjects that are extremely close. Also, the viewfinder is separate from the lens, so when you take close-ups, there is a significant difference between the image the camera "sees" and the image you see. This complicates composition.

These reservations aside, point & shoots provide convenience, portability, and spontaneity for outdoor photography. In particular, they are good for photographing well-lit landscapes, as well as for situations such as white-water rafting, skiing, trail running, or rock climbing where bulkier or more expensive cameras may be impractical. Useful features to look for in a point & shoot are a large, bright viewfinder; a wide zoom range (at least 38–90mm); a minimum focusing distance of less than 3' (the shorter, the better!); spot metering; weatherproofing; an infinity-lock feature; and backlight compensation.

⊲ ALTERNATIVES TO 35MM CAMERAS

Advanced Photo System. An alternative to 35mm cameras is the Advanced Photo System (APS), which uses a smaller film format. Each time you take an exposure, an APS camera allows you to choose between three different print-size options: a "classic" (C) format with the same ratio (3:2) of length to width as 35mm film, a "panoramic" (P) format that is three times as long as it is wide, and an "HDTV" (H) format that falls right in between the other two. When APS film is processed, in addition to the individual photos, you receive an "index print" that includes thumbnail-sized versions of all your photos. This makes it easy to choose photos for reprinting.

Most APS cameras are compact point & shoot models that autofocus and automatically set exposures. Film and processing costs for APS cameras are frequently higher than for 35mm cameras. APS cameras can only use APS film.

Medium-Format and Large-Format Cameras. There are two film formats larger than 35mm that are sometimes used by professional nature photographers. Medium-format cameras generally use 120 or 220 roll film to produce negatives

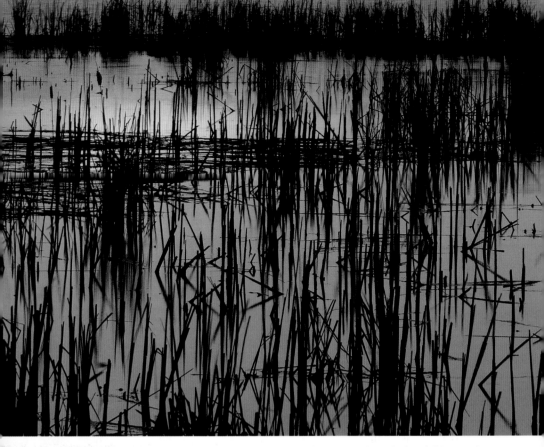

Because of their large film sizes, medium-format cameras produce extraordinarily detailed images that are wonderful for big prints. (Fernhill Wetlands, Forest Grove, OR; May; medium-format camera with 300mm lens and 2X teleconverter; Fujichrome Velvia; 1 sec. @ f/44)

or slides with sizes such as 6x4.5cm, 6x7cm, and 6x9cm. Large-format cameras use large individual sheets of film, typically 4"x5" or 8"x10".

Medium- and large-format cameras produce much larger negatives and slides than 35mm cameras. For instance, a 6x7cm slide has more than four times the area of a 35mm slide. Less enlargement of these bigger slides is needed to produce prints of a given size, so even poster-size prints are extremely detailed and sharp.

Medium- and large-format cameras are an unlikely choice for the average nature photo enthusiast. These larger cameras, and their lenses, film and processing are all substantially more expensive than 35mm systems. Many of these cameras lack advanced electronic features, such as auto-exposure and autofocus, that are standard on 35mm SLRs and even on point & shoots. These big cameras are also considerably heavier and more cumbersome.

Digital Imaging. Some of the most profound and most rapid technological changes in the 160+ years since the invention of photography are now underway. The technological wave of the future in photography is digital imaging. Digital cameras store images on an electronic

recording medium rather than on film. The images from a digital camera can be transferred to a PC and manipulated, printed, e-mailed, or posted on Web sites.

Over the next decade, a major shift will likely occur from film cameras to digital cameras. At present, the majority of nature photography is still done with conventional 35mm cameras and film. Increasingly, photographers are scanning conventional photos to convert them to a digital format for subsequent use.

To learn more about this timely topic, see the following books (also from Amherst Media):

Basic Digital Photography, by Ron
 Eggers
Beginner's Guide to Adobe® Photoshop®,
 by Michelle Perkins
*Traditional Photographic Effects with
 Adobe® Photoshop®*, by Michelle
 Perkins and Paul Grant
Basic Scanning Guide, by Rob Sheppard
*Digital Imaging for the Underwater
 Photographer*, by Jack and Sue
 Drafahl

✐ LENSES

Your photos are only as good as your lenses! Using the most expensive camera coupled with a cheap lens is like listening to music on a great stereo amplifier that has $25 speakers attached. Simply put, it doesn't work very well. Always use the best lenses you can; in nature photography, there is no substitute for high-quality lenses.

Lens Choices for SLRs. There are hundreds of lenses available for use with 35mm SLR cameras. A lens is identified

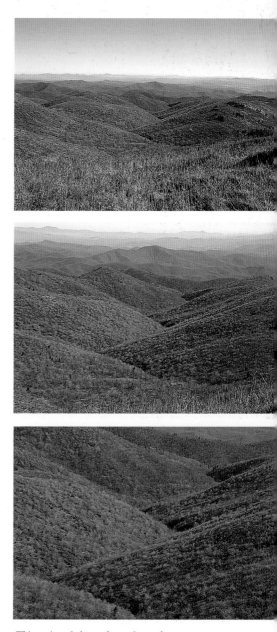

This series of three photos from the same vantage point illustrates the versatility of a zoom lens. The focal length used for the first photo was 28mm, the second was 60mm and the third was 120mm. (Pisgah National Forest, NC; November; 28–200mm zoom; Fujichrome Sensia 100; ⅟₆₀ sec. @ f/11)

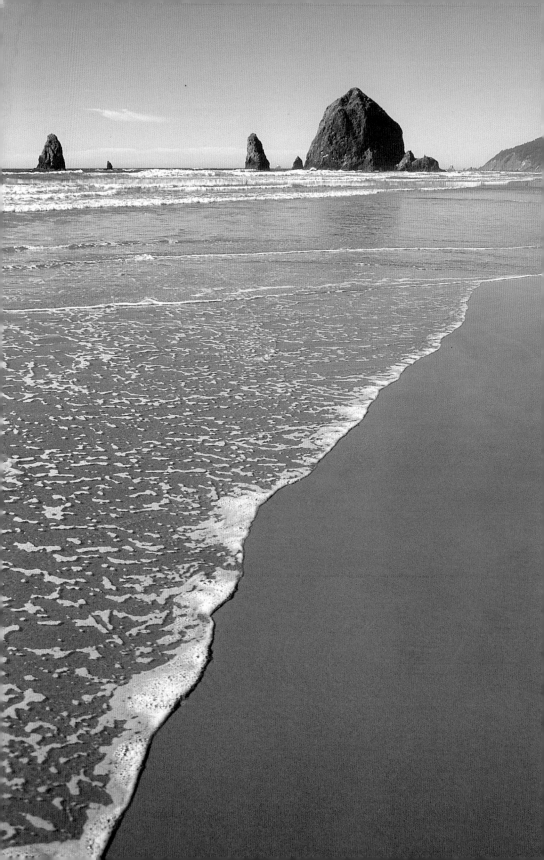

principally by its focal length, which is expressed in millimeters. In 35mm camera terminology, a lens with a focal length of approximately 50mm (about 2") is considered a standard lens. Any lens with a focal length significantly less than 50mm is a wide-angle lens, for example, a 24mm, 28mm or 35mm lens. Wide-angle lenses literally show you a wider angle of view; the shorter the focal length, the wider the angle of view. Any lens with a focal length significantly more than 50mm is a telephoto lens—for example, a 90mm, 135mm or 300mm lens. Telephoto lenses magnify the subjects you view; the longer the focal length, the greater the magnification of the scene. Telephotos also compress space so that near and distant objects appear closer to one another.

For nature photography, zoom lenses are especially useful. Unlike single-focal-length lenses, a zoom lens covers a range of focal lengths, and thus allows you to frame a scene in a variety of ways. For instance, a 28–70mm zoom lens extends from a moderate wide-angle focal length (28mm) to a short telephoto focal length (70mm). A 70–300mm lens extends from a short telephoto focal length (70mm) to a moderately long telephoto focal length (300mm) suitable for photographing wildlife.

Facing Page: A 17mm lens provided an extremely wide angle of view for this coastal scene. The foam at the edge of the surf forms a distinct line that leads the viewer's eye from the lower left corner of the frame toward the rocky islands in the background. (Cannon Beach, OR; September; 17mm lens; Fujichrome Sensia 100)

Zoom lenses maximize convenience; the combined range of focal lengths of the two zooms mentioned above will likely cover more than 90% of your photo needs. If you photograph a lot of big landscapes, you may want to get an extreme wide-angle lens such as a 17mm or 20mm lens. If you love to photograph birds, then a telephoto lens longer than 300mm is useful, but be aware that such lenses are expensive, heavy, and nearly always need to be steadied with a tripod!

Lens Choices for Point & Shoot Cameras. As noted earlier, point & shoot cameras do not have interchangeable lenses; the lens is permanently built into the camera. In terms of lenses, point & shoots come in three main varieties:

Wide-angle lens—These are basic cameras with a single-focal-length wide-angle lens, usually with a focal length between 28mm and 35mm; they are particularly good for photographing expansive landscapes.

Standard zoom lens—These are cameras with a wide-angle-to-short-telephoto zoom lens, usually 35–70mm or thereabouts; they work well for photographing a variety of landscapes and for taking nature portraits.

Extended-range zoom lens—These are cameras with a wide-angle to medium telephoto zoom lens; popular combinations include 38–120mm and 38–140mm. The longer focal lengths increase your reach for photographing wildlife. Unfortunately, the light-gathering ability of these extended zoom lenses is poor at the

longer focal lengths; this necessitates use of high-speed films (ISO 400 or higher) to photograph wildlife.

◀ CAMERA CARE

The rigors of outdoor photography can be tough on your camera and lenses. A few guidelines are helpful to ensure that your photo equipment has a long and useful life. Keep your equipment as dry as possible. When you photograph in rain or snow, keep your camera covered except when you are actually taking pictures.

Thick plastic bags are handy for protecting your camera. When you return from the field, promptly dry your camera, lenses and tripods with a soft towel. *Do not microwave your camera!*

In coastal locations, avoid getting sand or saltwater in your camera. Tiny grains of sand can wreak havoc with moving parts, and salt spray can cause internal components to rust. Never leave your camera uncovered on a beach towel! In the field, in the car and at home, always protect your camera from dust and extreme heat.

Photo Accessories

⌇ FILTERS

Photographic filters are supplementary lens attachments that are either screwed onto the front of a lens or mounted in a bracket attached to the lens. Filters can be used on virtually any SLR lens, but they are rarely made for use on point & shoot cameras. Of the dozens of kinds of filters available, only a few are widely used for nature photography with color film. These popular filters are described below.

The polarizing filter is an extremely popular filter for outdoor photography.

Ultraviolet, Haze and Skylight Filters. Ultraviolet (UV), haze and skylight filters have very little effect on the quality of color photographs. Each of these filters is principally used by nature photographers to protect the front of the lens. Some photographers always keep one of these filters on the front of each lens to avoid any damage to the lens. Use of these filters is a particularly good idea if you plan to bushwhack, scramble over boulders, or photograph near waterfalls or in coastal areas with salt spray.

Polarizing Filters. The polarizing filter or polarizer is an extremely popular filter for outdoor photography. Polarizing filters have three major effects in outdoor photography:

1. Polarizers can remove reflections from shiny surfaces such as a pond or lake.
2. Polarizers can deepen the blue of the sky and increase the contrast between sky and clouds.
3. Polarizers can increase the overall color intensity in a scene.

When you put a polarizer on your lens, you can rotate it in its mount until you see the desired effect through your viewfinder. Thus you can selectively reduce reflections on water, deepen sky colors, or increase color intensity. A polarizer has the greatest effect on skies when the sun is at your side—at a right angle to the direction you are pointing your camera—and has minimal effect when the sun is directly in front or directly in back of you. The reflection-cutting effect of a polarizer is maximized when your camera's line of sight is at a 35° angle to the reflective surface, such as the surface of a lake.

The first photo in this series was taken without a filter. The second was taken with a polarizing filter, which produced both a bluer sky and more vivid foliage. The third was taken with a graduated neutral density filter, which reduced the contrast between land and sky. (Jackson-Frazier Wetland, Corvallis, OR; 28–200mm zoom set at 70mm; Fujichrome Sensia 100; first exposure: ⅓₀ sec. @ f/16, second and third exposures: ⅛ sec. @ f/16)

Many photographers like the blue skies and intensified colors produced by a polarizer. Be judicious when you use this filter; it sometimes deepens sky colors so much and removes reflections so completely that a natural scene is transformed into a surreal image. If you own an autofocus SLR, you probably need a special type of polarizer known as a "circular polarizer", see your camera owner's manual to verify this.

Graduated Neutral Density Filters. The human eye is far better than color film at perceiving high-contrast scenes. When you photograph a scene such as a sunrise that is split almost half-and-half between bright sky and much darker-toned land, your film is unable to reproduce the full range of contrast. Either the lighter areas end up with a washed-out appearance, or the darker areas end up as featureless blocks of black. A graduated neutral density filter, which is half gray and half clear, can effectively darken the lighter parts of the scene, thus reducing the overall contrast in the scene to a reproducible level.

Warming Filters. The vast majority of nature photography is done without colored filters, but there is one colored filter, a warming filter, that is widely used. Warming filters have an amber cast that gives photos a "warmer" look. These filters are named 81A (weakest tint), 81B (moderate tint), 81C (stronger tint) and so forth. Some nature photographers mainly use a warming filter in overcast situations where the landscape is dominated by "cool" blues, greens and grays. An 81A or 81B warming filter is a good cure for a temporary case of the photographic blues! Other nature photographers use a warming filter to intensify subjects such as sun-

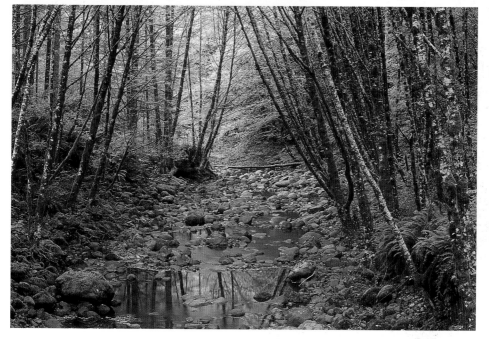

On a mostly cloudy autumn day, an 81A warming filter gave the second photo a warmer cast, which is preferred by some photographers. (Tillamook State Forest, OR; October; 75–300mm zoom set at 75mm; Fujichrome Sensia 100; 10 sec. @ f/22)

sets or autumn leaves that already have a warmish cast.

TRIPODS

A tripod is a vital accessory for nature photography. Nearly all cameras today—yes, even most point & shoot cameras—have a tripod socket on the bottom, and a basic tripod is surprisingly inexpensive (about $40) and lightweight (three pounds).

When you shop for a tripod, take your camera and largest lens to the store, and consider the following five factors:

1. Make sure the tripod is heavy enough to support your camera and your largest lens in a stable fashion on uneven terrain in a stiff breeze.
2. Make sure the tripod is light enough to carry on your photo excursions. A

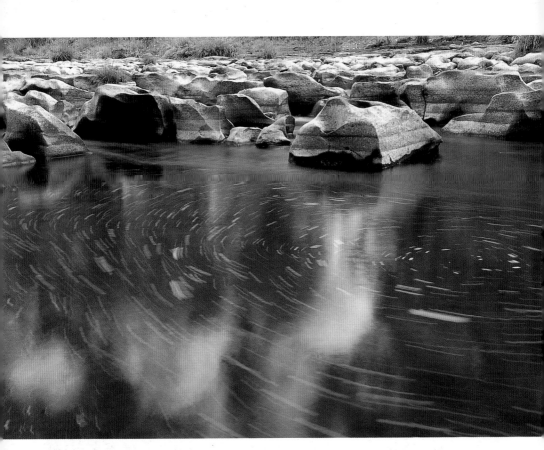

Professional nature photographers take their tripods almost everywhere. A tripod lets you make long exposures to record motion such as leaves swirling in an eddy. (Alsea River, Siuslaw National Forest, OR; October; 28–200mm zoom set at 45mm; Fujichrome Sensia 100; 4 sec. @ f/27)

tripod of more than five pounds is too heavy for many people to comfortably carry. Most tripod manufacturers now offer carbon fiber tripods that combine strength and stability with lighter weight; the drawback is a price of $270 and up.

3. Check how low the tripod will allow you to get; this is very important for close-up photography of wildflowers and small animals.

4. Check how easy it is to adjust the tripod head—the part the camera attaches to—and to aim the camera in various directions at all angles.

5. Check to see if the tripod head has a quick-release mount that allows you to quickly attach and remove your camera from the tripod.

When using a tripod, be sure to firmly attach the camera to the tripod and always make sure the tripod is stable before you take a photograph. To avoid shaking your tripod-mounted camera while photographing, use the camera's self-timer, a cable release or the electronic remote switch that is available for some cameras.

Many SLRs and virtually all point & shoot cameras today have built-in electronic flash units. These units are not particular-ly powerful; no, you can't light up the Grand Canyon for the perfect landscape photo at sunset! But you can improve many of your nature photos through judi-

With your camera mounted on a tripod, you can slow down and carefully compose your images. Tripod use greatly increases the probability that you will produce a well composed, sharply focused, and correctly exposed photo. (Appalachian Trail, Beartown State Forest, MA; October; medium-format camera with 135mm lens; Kodak Ektachrome 100)

cious use of the camera's automatic flash. In particular, "fill-in" flash is useful to augment available outdoor light for daytime nature photography of flowers and other close-up subjects. Check your camera owner's manual to determine the effective working distance of your built-in flash and to learn about the various flash modes programmed into your camera.

If your SLR does not have a built-in flash but you do a lot of wildflower photography, you may find it useful to purchase a separate flash. Flashes have various degrees of electronic compatibility with particular cameras; for convenience, shop for a "dedicated" flash that is specifically made to work with your SLR.

✒ BATTERY TIPS

Occasionally a camera may electronically freeze up for no apparent reason. The shutter will not release and the film will not advance. If this happens, turn the camera off and remove the battery. Wipe the battery with a soft cloth, then put it back in the camera. This will often solve the problem.

Keep in mind that the performance of camera batteries drops significantly at lower temperatures. When temperatures are below freezing, keep the camera close to your body—for example, beneath a parka or sweater—when you are not photographing. This will keep the batteries warm and functioning. If your batteries appear to die when you are photographing on a cold day, you may be able to revive them. Simply remove the batteries from the camera and warm them for a few minutes in your hand or against your body, then put them back in the camera.

One more tip—always carry an extra battery!

Film

◢ FILM SPEED

The sensitivity of photographic film to light is rated on a standard scale known as ISO. A film's ISO rating is also referred to as the film speed; this rating appears prominently on the film packaging. The higher the ISO rating, the more sensitive the film is to light. For instance, an ISO 200 film is twice as light sensitive as an ISO 100 film. In practical terms this means that, to produce a particular exposure, the ISO 200 film only needs to receive one-half as much light as the ISO 100 film.

Films rated at ISO 100 or ISO 200 are good all-purpose films for many everyday uses.

Medium-Speed Films for General Use. Films rated at ISO 100 or ISO 200 are good all-purpose films for many everyday uses. These films are a versatile choice for most natural lighting conditions and most subjects; they are widely used for wildlife photography in particular. They have excellent color rendition and pleasing levels of contrast.

Slow Films for Sharpness. Much of the nature photography that appears in magazines, calendars, and coffee-table photo books is produced with "slow" slide films that have an ISO rating of less than 100. In particular, Kodachrome 64 and Fujichrome Velvia (ISO 50) slide films have a loyal following among nature photo pros. In addition to beautiful color reproduction and pleasing levels of contrast, they are extremely fine-grained, very sharp, and can record delicate detail. Even when enlarged to 8"x12" or beyond, photos taken with these films are impressive for their sharpness and absence of graininess. All but a handful of the illustrations in this book were taken with Kodak and Fuji slide films with speeds of ISO 100 or slower; the captions identify cases when faster films were used.

Of course, slow films have a significant disadvantage compared to medium-speed films in that they need a lot more light to produce an acceptable exposure. Many excellent nature photo situations are in very low light—for example, in a dense evergreen forest or in a swamp at dusk. If animals or windblown flowers are moving in a low-light scene, slow films may not allow for a fast enough shutter speed, and the motion will appear blurred in your photos.

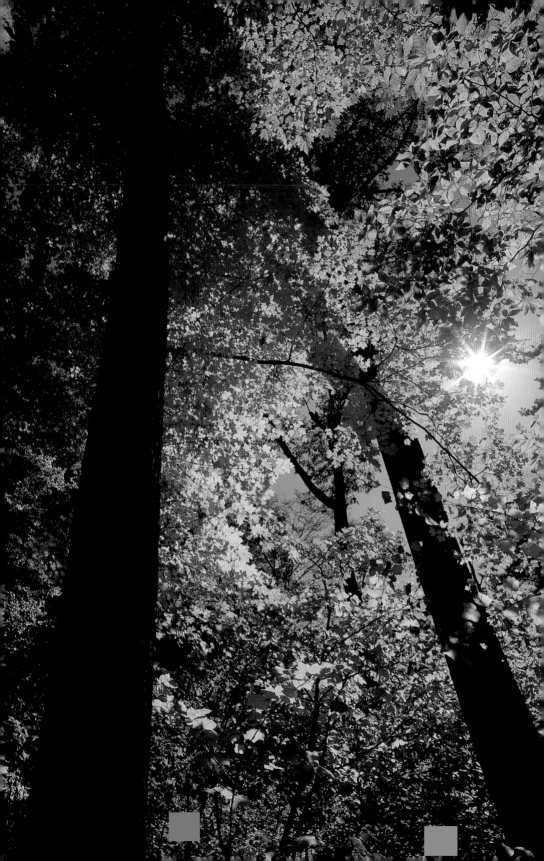

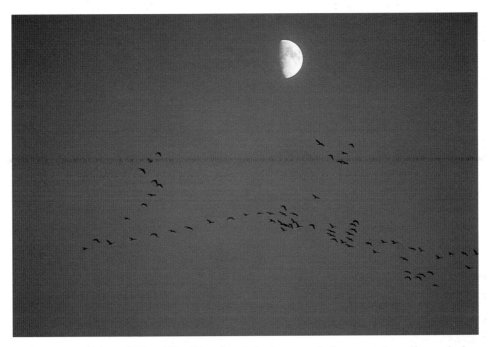

Light-sensitive, high-speed film—ISO 400—allowed for just enough shutter speed to photograph these Canada geese in Oregon flying beneath the moon at dusk. (Fernhill Wetlands, Forest Grove, OR; November; 75–300mm zoom set at 300mm; Kodak Ektachrome 400; ¹⁄₆₀ sec. @ f/5.6)

High-Speed Films for Special Situations. At the opposite end of the film-speed spectrum are high-speed color films of ISO 400, 800, and even 1600. That's really fast! The strong point of high-speed films is that they can produce good exposures even in very low light. ISO 400 is an excellent choice when you want to photograph animals in low light situations or if you are taking close-ups of wildflowers that are blowing in the breeze. High-speed films allow for faster shutter speeds to photograph motion without blurring. They are also favored when you are literally photographing in the dark, for instance, if you are photographing the

northern lights, a meteor shower, or other astronomical subjects.

Since high-speed films allow you to photograph in very low light conditions, you may wonder why nature photographers do not use these films all the time. Unfortunately, high-speed films have drawbacks. In addition to their higher prices, color print films faster than ISO 400 and slide films faster than ISO 200 are often significantly grainier, less sharp, and less able to reproduce fine detail than slower films. When color photos taken on very high-speed films are enlarged to 8"x12" or larger, graininess and loss of sharpness may be noticeable. Of course,

Facing Page: Fujichrome Velvia, an ISO 50 slide film, demonstrates its terrific sharpness and beautiful colors in this image of autumn foliage in the Berkshires. (Stockbridge, MA; October; medium-format camera with 45mm lens; Fujichrome Velvia)

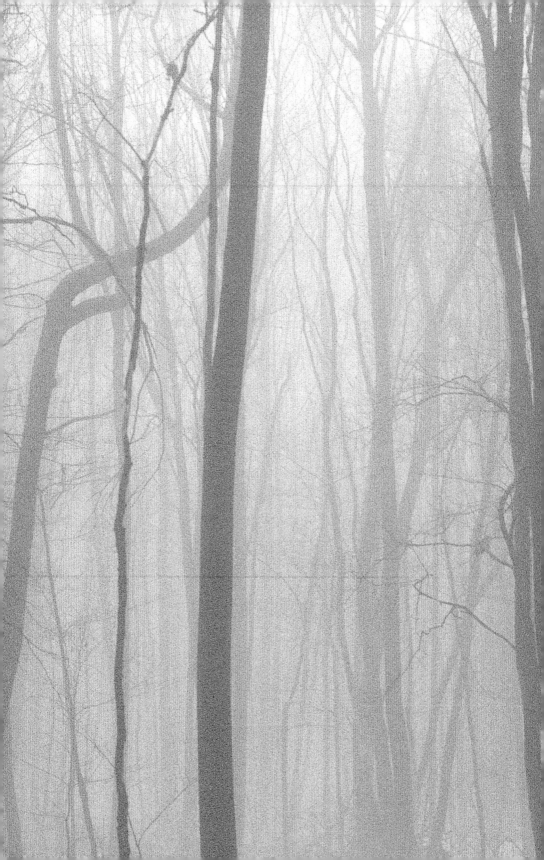

some photo subjects, for instance, snow falling in a foggy forest, may actually be enhanced by grainy film. Use high-speed films selectively and keep in mind that an ISO 800 film will often give you a substantially different photo than an ISO 100 film.

PRINT FILM OR SLIDE FILM?

Both color print film and slide film are extensively used in nature photography. Print film is a "negative" film; the exposed film is chemically processed to produce negatives that are then printed on photographic paper. Slide film is a "positive" film that is processed, then cut and placed in slide mounts; there is no negative. Slides are also referred to as "transparencies" or "chromes." Slide films typically have the word "chrome" in their names. Your decision about whether to use print or slide film may depend on the following factors:

Cost—The cost of film and processing vary greatly. In many cases you will

Film choice is very subjective! Consider how you use your photos to decide whether to use print or slide film, and consider color palette, sharpness, level of contrast, and film speed to select which particular film to use. (Rocky Mountain National Park, CO; August; medium-format camera with 135mm lens; Fujichrome Provia 100)

Facing Page: *The grainy softness of extremely high-speed film is ideal for this peaceful forest scene on a foggy afternoon in a snowy Appalachian forest with little ambient light. (Coopers Rock State Park, WV; January; 90mm lens; Scotch Chrome 1000; 1/60 sec. @ f/4)*

find that print film is much less expensive to buy, but that processing costs are higher than for slide film.

Usage—What do you like to do with your nature photos? Many people simply enjoy having prints to show to family and friends, and to put into albums. You can also get color slides made into prints, but the cost of doing this with all your favorite photos is prohibitive. If you want to use your photography for teaching or publication, then slides are often the preferred medium. If you plan to amass a large collection of photos of plants or animals, then slides may be the best choice, because of the ease of labeling, filing and subsequently retrieving them.

Exposure latitude—Color slide films have much narrower exposure latitude than color print films. This means that the exposure must be much more precise to produce an acceptably exposed photo with slide film. In essence, color print film is much more "forgiving" of exposure errors. This is partly because of the film chemistry, and partly because errors in exposure on print film are corrected to some degree when the negatives are printed at your local photo lab.

The vast majority of amateur photographers use color print film, whereas the vast majority of nature photo pros use color slide film. Many pros prefer the sharpness and vivid colors of slow slide films for optimal image quality, but their choice of slide film also has a lot to do with how they use their images in publishing projects and in slide presentations.

FILM CHOICES

There are more than 100 different color films available. So what's a beginning nature photographer to do? Is there really one brand of film that is best? The answer is that film choice is very subjective, and you are the best judge of what film to use. If you want to learn more about film, try out four or five varieties—different brands and different speeds—and carefully study your results. The most important thing is to find a film that you like to use in most outdoor photo situations.

CHAPTER FOUR

Exposure

✎ EXPOSURE MODES

Exposure is determined by the intensity and duration of light that reaches your film. The ideal camera allows you to set exposures manually, use semi-automatic exposure settings or use totally automatic exposures. Most SLRs today have this versatility and offer the following exposure modes:

Program mode *("P" on many cameras)*—Your camera's micro-chip "brain" is programmed to automatically select an appropriate exposure based on your film speed and the amount of reflected light from your photo subjects that reaches your camera. Your camera chooses the proper amount of light from the outside world to expose to your film to produce a good photo.

Exposure is determined by the intensity and duration of light that reaches your film.

Aperture-priority mode *("Av" or "A" on most cameras)*—You set the aperture (f-stop), then the camera chooses an appropriate shutter speed. This is a popular shooting mode among nature photographers because the choice of aperture, as explained later in this chapter, is often your top priority in setting the exposure.

Shutter-priority mode *("Tv" or "S" on most cameras)*—You set the shutter speed, then the camera instantaneously chooses an appropriate aperture. This mode is useful to photograph fast-moving wildlife.

Manual mode *("M" on most cameras)*—You set both the aperture and shutter speed. This mode maximizes your control over each exposure.

Many cameras today also have other subject-specific exposure modes. For instance, an "action" or "sports" program mode (symbolized by a sprinter icon) preferentially chooses faster shutter speeds to freeze motion. Most point & shoot cameras only offer program modes; it is not possible to manually set their apertures and shutter speeds. See your owner's manual for descriptions of your camera's exposure modes.

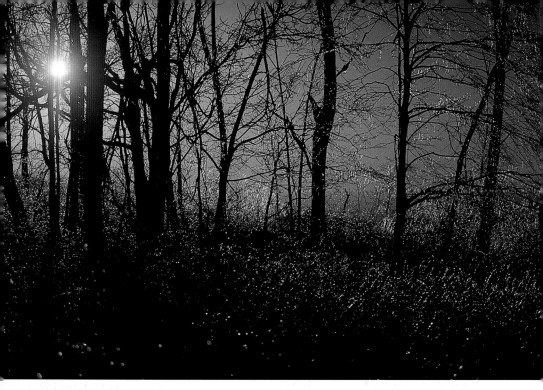

The exposure modes offered by your camera are tools to help you work creatively with the nearly infinite range of ambient lighting conditions in the outdoor world. A late winter ice storm and strong backlighting by the sun created this glittering forest landscape. (Forbes State Forest, PA; March; 28–70mm zoom; Fujichrome 50)

◀ MANUALLY SETTING EXPOSURES

If your camera allows you to set shutter speeds and apertures (f-stops), then you can manually control exposure and creatively fine-tune your photos. To do this, you need to understand shutter speed and aperture, and the important relationship between these two variables.

What Is Shutter Speed? Shutter speed refers to the amount of time your camera's shutter stays open—thus allowing light to reach the film—when you take a picture. Cameras use a standard series of shutter speeds measured in fractions of a second (DIAGRAM 1).

Each of these shutter speeds is twice as long as the one listed above it and one-half

Right: Diagram 1

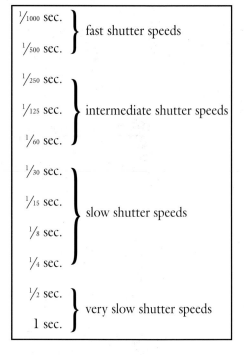

$\frac{1}{1000}$ sec.	fast shutter speeds
$\frac{1}{500}$ sec.	
$\frac{1}{250}$ sec.	intermediate shutter speeds
$\frac{1}{125}$ sec.	
$\frac{1}{60}$ sec.	
$\frac{1}{30}$ sec.	slow shutter speeds
$\frac{1}{15}$ sec.	
$\frac{1}{8}$ sec.	
$\frac{1}{4}$ sec.	
$\frac{1}{2}$ sec.	very slow shutter speeds
1 sec.	

as long as the one listed below it. Changing the shutter speed by one "stop" means changing from one shutter speed to either the one listed above it or below it.

Some cameras will allow you to use shutter speeds faster than $^1\!/_{1000}$ sec., such as $^1\!/_{2000}$ sec. or even faster. SLRs allow you to use shutter speeds of longer than 1 sec. by setting the shutter speed to a value of multiple seconds, or by setting the shutter speed to "B" and manually keeping the shutter open with a cable release or electronic remote switch. Some point & shoots, particularly high-end models, have a "B" mode for long exposures.

Most modern cameras also allow you to use shutter speeds that are intermediate between the shutter speeds listed in this series; these in-between shutter speeds are at "half-stop" intervals, for example, $^1\!/_{90}$ sec. is a half-stop faster (shorter) than $^1\!/_{60}$ sec. and a half-stop slower (longer) than $^1\!/_{125}$ sec. shutter speed. With all these possible shutter speeds to choose from, how do you select the right one?

How to Choose Shutter Speeds. Your choice of shutter speed is critical when your photo subject is moving. If you use slow shutter speeds—$^1\!/_{30}$ or $^1\!/_{15}$ sec., for example—to photograph moving animals or flowers blowing in the breeze, your

Setting your shutter speed to "B" lets you keep the shutter open as long as you want to gather the faint light of the night sky. The star trails are figuratively the tracks of the spinning earth . . . think about it! (Kalmiopsis Wilderness, Siskiyou National Forest, OR; August; 28–200mm zoom set at 28mm; Fujichrome Provia 100F; 12 min. @ f/4)

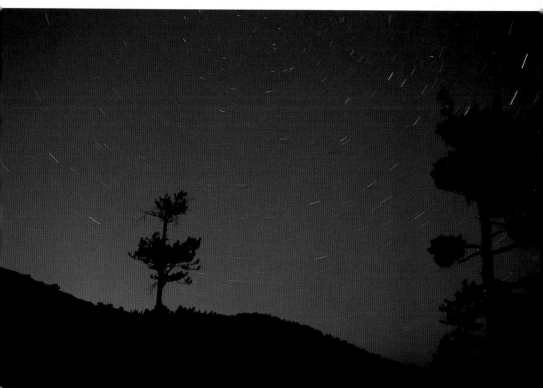

A shutter speed of ¹/₁₂₅ sec. is just fast enough to give a sharp image of a black oystercatcher preening. (Hug Point State Park, OR; August; 28–200mm zoom set at 200mm; Fujichrome Sensia 100; ¹/₁₂₅ sec. @ f/5.6)

photo subjects will be blurred. A fast shutter speed, ¹/₁₀₀₀ sec., for instance, will nearly always freeze the motion of a moving animal, and thus can produce a sharp image. When the animal's motion is slow or when the animal is far enough away to appear quite small in the image, a shutter speed of ¹/₁₂₅ or ¹/₂₅₀ is often adequate. The best way to determine what shutter speed is necessary in a particular situation is to learn from your experience.

If you do not use a tripod, "camera shake" will often produce blurred images when you use slow shutter speeds. Most people cannot hold the camera perfectly still for more than a small fraction of a second. A useful guideline when you hand-hold your camera is that you should not

Right: Diagram 2

use a shutter speed slower than the reciprocal of the focal length of your lens. For example, if you are using a 35–70mm zoom lens set at 60mm, you should try to avoid using shutter speeds longer than ¹/₆₀ second. So ¹/₁₂₅ sec. or ¹/₂₅₀ sec. would be okay, but ¹/₃₀ sec. or ¹/₁₅ sec. would not be. Through experience you will learn what works for you!

What Is Aperture? Aperture refers to the size of the lens opening through which light passes to reach your film. Camera

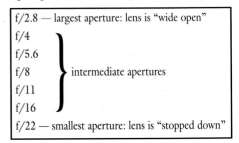

f/2.8 — largest aperture: lens is "wide open"
f/4
f/5.6
f/8 } intermediate apertures
f/11
f/16
f/22 — smallest aperture: lens is "stopped down"

lenses use a standard series of apertures expressed as f-stops (DIAGRAM 2).

On particular lenses, this series of f-stops may not extend quite so far or the series may extend further in either direction, for example, to f/2 or f/32. Apertures are written this way because each aperture is defined as the focal length ("f") of the lens divided by a particular number. For example, when a 100mm lens is set at f/4, the diameter of the lens opening is 100mm/4 = 25mm. The good news: You don't need to remember this formula to take excellent photos!

All you need to know is that this series is set up so that each aperture allows in twice as much light as the one below it and half as much light as the one above it. Changing the aperture by one "stop" means changing from one aperture to either the one listed above it or below it. Your lenses also may allow you to set apertures at half-stop intervals, for example, at f/19, halfway between f/16 and f/22.

The largest aperture of a particular lens is referred to as the "lens speed," and a lens is identified both by its focal length(s) and its lens speed. For example, a 300mm f/2.8 lens is said to be one stop "faster" than a 300mm f/4 lens. The 300mm f/2.8 lens has twice the light-gathering ability of the 300mm f/4 lens, and thus can be used effectively in lower light conditions. The value of fast telephoto lenses becomes evident when you photograph wildlife in low light. Most zoom lenses today have a lens speed between f/3.5 and f/5.6; faster zoom lenses are available at considerably higher prices.

Increments of aperture and increments of shutter speed are both measured in stops. When you change either aperture or shutter speed by one stop, you either halve or double the light that will reach the film. Because of this reciprocal relationship between changes in shutter speed and changes in aperture, in any given situation you have the choice of several different combinations of aperture and shutter speed to expose your film to the correct amount of light. For example, if your camera's built-in exposure meter indicates that f/11 at 1/250 sec. is a correct exposure,

Your choice of aperture has a major effect on the appearance of your photos because a smaller aperture (a higher f-stop number) causes more of the photo to appear in focus. The first photo was made at f/5.6; the second one was made at f/32 and thus has much more depth of field. (Portland, OR; April; 28–200mm zoom set at 100mm; Fujichrome Sensia 100; 1/60 sec. and 1/3 sec.)

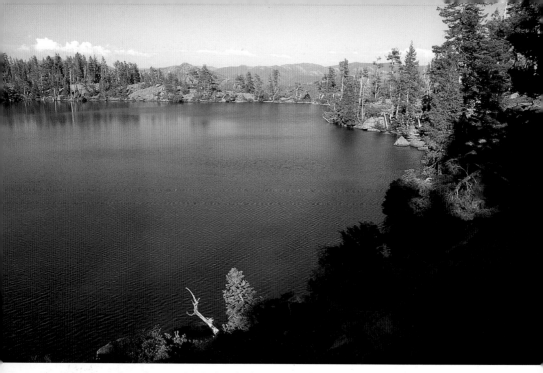

As you compose through your viewfinder, depth-of-field preview lets you see the front-to-back zone of sharpness in the scene exactly as it will appear in your photo. This is extraordinarily helpful as you select the optimal aperture. (Vulcan Lake, Kalmiopsis Wilderness, Siskiyou National Forest, OR; August; 28–200mm zoom set at 28mm; Fujichrome Sensia 100; 1/60 sec. @ f/11)

then f/8 at $^{1}/_{500}$ sec., f/5.6 at $^{1}/_{1000}$ sec., f/16 at $^{1}/_{125}$ sec., and f/22 at $^{1}/_{60}$ sec. would also allow the same amount of light to reach the film. So how do you select which aperture to use?

How to Choose Apertures. As noted earlier, proper choice of shutter speed is critical when you photograph moving subjects and when you handhold your camera. If your photo subject is not moving and you have mounted your camera on a tripod, then selection of aperture takes precedence over choice of shutter speed. Aperture is important because it helps determine the depth of field in your photos. Depth of field refers to the range of distances, from near to far, that appears sharply focused in a photo. This zone of sharpness extends from some distance in front of the point on which your lens is focused to some distance behind the point on which your lens is focused. The depth of field in photos can vary from fractions of an inch to more than a hundred miles!

The smaller your lens aperture, the greater your depth of field. If you set your lens at f/16 or f/22—small apertures—you will have much more depth of field than at f/2.8 or f/4—large apertures. You may find it useful to think of yourself as "dialing in" the preferred amount of depth of field; apertures such as f/2.8 and f/4 give less depth of field, f/16 and f/22 give more.

Please note that depth of field also depends on the focal length of the lens

(the longer the focal length, the less depth of field), and on the distance at which the lens is focused (the greater the focusing distance, the greater the depth of field). There are three ways to determine how much depth of field you have in a given situation:

1. Some lenses have a depth-of-field scale marked on the top of the lens barrel. Owner's manuals for lenses explain how to use this feature.
2. Depth-of-field tables are available in photo reference books as well as at many Internet photo sites.

As you become more experienced, you will gain a greater appreciation of how your choice of aperture, the focal length of your lens, and your focusing distance each play a role in controlling depth of field in your photos. (Rocky Mountain National Park, CO; August; medium-format camera with 135mm lens; Fujichrome Velvia)

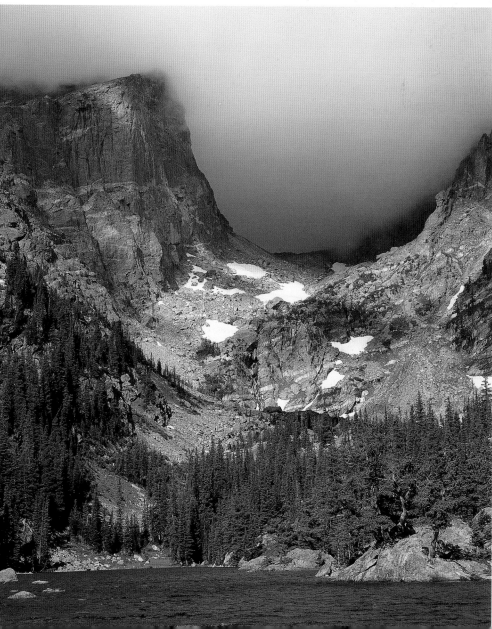

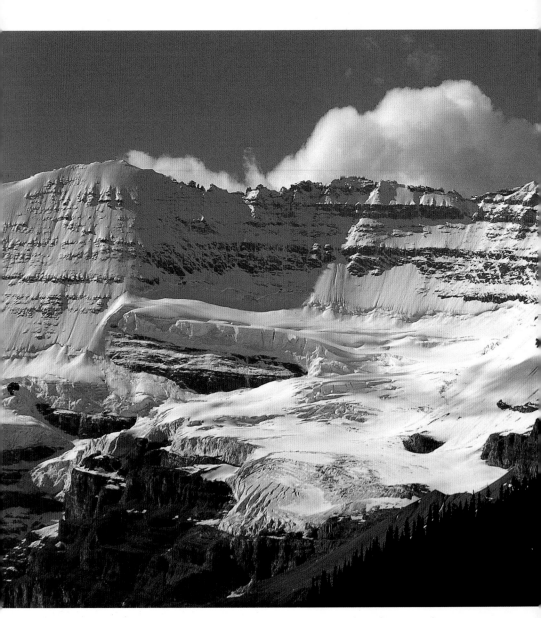

If you are unsure of the proper exposure, then "bracket" your exposures by making more than one exposure with slightly different apertures or shutter speeds. This strategy increases your odds of producing a photo you really like. (Victoria Glacier, Banff National Park, Alberta, Canada; October; 70–210mm zoom lens; Kodachrome 25)

3. A depth-of-field preview feature built into some SLRs lets you see the actual depth of field through your viewfinder. When you push the depth-of-field preview button, you are manually "stopping down" the lens diaphragm to the aperture at which the lens is set. Then you see the depth of field as it will appear in your photo, and you can decide whether the visual effect is really the way you want it. Without this feature your viewfinder always shows you the image the way it would appear with your lens at the largest aperture and with the least depth of field.

◢ EASY EXPOSURE SITUATIONS

When your camera's built-in exposure meter judges how to expose a particular scene, it is measuring the amount of light reflected toward the camera from various parts of the scene. Exposure meters are calibrated to choose an exposure that will reproduce an overall medium-gray tone in the image; this medium gray is a middle tone in between white and black. So your meter works fine when the scene you photograph is largely made up of middle tones, and your camera will often automatically select a suitable exposure. This is true in many outdoor scenes, for example, if the composition is dominated by well-lit green leaves, green grass or gray tree bark.

◢ NOT-SO-EASY EXPOSURE SITUATIONS

You sometimes encounter tricky situations where your exposure meter does not automatically choose an optimal exposure. When the film is exposed to too much

light, the photo comes out too light and is an overexposure; colors appear less vivid, and the image may even appear washed out. When the film is not exposed to enough light, the photo comes out too dark and is an underexposure.

A challenging situation in nature photography is a scene dominated by shades that are considerably lighter than a medium-gray tone, for example, a white sand beach, a snowy landscape or sun reflected off the surface of water. Your exposure meter expects the world to be a medium-gray tone on average, and the meter suggests exposures that will produce middle-toned photos. Consequently, photographs of white or very bright subjects often come out grayish, not white, because they are underexposed.

When you encounter these scenes that are much lighter than medium gray, think of the phrase, "add light to light." Purposely overexpose ("add light") compared to your exposure meter reading. If your camera has manual exposure control, then overexpose between $\frac{1}{2}$ and two stops compared to your exposure meter reading by opening up the aperture or using a slower shutter speed. In difficult exposure situations, you can learn a great deal when you take two or three exposures of the same scene with slightly different exposure settings. This technique of making an exposure at the metered setting, then making additional exposures at other settings varying from one another by half or full stops is called "bracketing" exposures.

Pay attention to the influence of the sky on your exposure meter. Note how shaded tree trunks and leaves appear in silhouette in this forest scene. (Joyce Kilmer-Slickrock Wilderness, Nantahala National Forest, NC; August; medium-format camera with 135mm lens; Fujichrome Velvia)

Write down the settings you use, then review your photos to determine what works.

On a related note, many point & shoot cameras have a "backlight compensation" feature that allows you to purposely alter the exposure when your main point of interest in the photo is strongly backlit. Use of this feature causes the camera to overexpose the scene compared to the meter reading. This increases the amount

Facing Page: Add light to light! This intensely sunlit, white-water creek was much lighter than a medium gray tone. An intentional overexposure of one stop—compared to the metered exposure—yielded a photo with brightness matching the actual scene. (Delaware Water Gap National Recreation Area, PA; August; 75–300mm zoom set at 100mm; Fujichrome 100; $\frac{1}{4}$ sec. @ f/22)

of light the film is exposed to, thus brightening up your backlit subject, which otherwise might appear very dark against a lighter background. You may also want to use this feature when the sun is in your composition or when most of the scene is extremely light-toned.

Most SLRs and some point & shoot cameras give you the option of using a built-in spot meter. This is an exposure meter that only evaluates a small "spot" in the center of the scene in your viewfinder. In high-contrast exposure situations, one strategy to get a correct exposure is to use your camera's spot meter to read the light from the most important subject in your photo. As a general rule, if you use color print film, lean toward metering darker parts of the image; if you use color slide film, lean toward metering lighter parts.

Composition

◀ CLARIFY YOUR MESSAGE

Photos communicate. Good nature photos communicate well! Photographic composition refers to the arrangement of visual elements in a photo. As a photographer, you use lines, shapes, colors, tones, patterns, textures, balance, symmetry, depth, perspective, scale, and lighting to bring your images to life. But to consider the interplay of all of these visual elements in every photo is daunting. A more practical approach to nature photo composition is to look through your viewfinder and ask yourself two questions. (You probably shouldn't ask these questions out loud, or else nearby people and animals will wonder why you are talking to yourself.)

Photos capture moods, transmit information, and tell stories. As you compose each scene in your viewfinder, consciously identify the message you hope to communicate. (Fernhill Wetlands, Forest Grove, OR; January; 28–200mm zoom set at 200mm; Fujichrome Provia 100F; ½ sec. @ f/16)

1. What is the message of this photo?
2. What is the best way to communicate that message?

Nature photos are successful when the message is clear. When the photographer's message is garbled, ambiguous, weak or obscured by distracting visual elements in the composition, the photo is not a keeper. Nature photos that convey a powerful message compel the viewer to take a second look in order to soak in the beauty and meaning of the image.

◀ KEEP IT SIMPLE

The single best watchword to keep in mind as you compose photos is *simplicity*.

Instead of trying to squeeze lots of subjects into a photo—a flock of geese, a wildflower meadow, a spectacular sunset and dear Aunt Thelma standing on her head—aiming for simplicity is often the best strategy. Interestingly, some professional nature photographers actually take a "subtractive" approach to composition rather than an "additive" approach; instead of dwelling on what they can add to the composition, they focus on what can be removed in order to strengthen the composition.

In many cases, a poor composition can be turned into a good composition by fine-tuning through the viewfinder; that is, by moving the camera slightly left,

Simplify! Once you settle on a photo subject and roughly line it up in your viewfinder, move your camera left, right, up and down to see if you can improve the composition. This photo distills a craggy landscape into three zones: blue sky, gray rock and dark shadows. (Rocky Mountain National Park, CO; 28–70mm zoom; Kodachrome 25)

right, up or down with simplicity as a goal. Compositions suffer when your message is diluted by unwanted visual distractions. Avoid visual clutter and your compositions will sing!

BE PATIENT

Good photo composition takes time; great photo composition takes even more time. Nature photos composed in ten seconds or less usually bear little resemblance to those composed in ten minutes or more. There are occasions in wildlife photography when you must rapidly point and shoot or else you will miss the opportunity altogether, but many nature photo subjects change very slowly. When you slow down to meticulously compose photos, the rewards may include a wonderful meditative experience along with vast improvement in your photos. How much better would your nature photos be if you spent at least ten minutes composing each one?!?

FILL THE FRAME

Just as a landscape painter would not leave a portion of the canvas totally blank, you should not ignore any portion of the scene that you frame in your viewfinder. Make the best use of the entire "canvas" of each photo. When you look through the viewfinder, think of it as a rectangular picture frame; as you compose, make use of all the available space. Fill the frame!

You can significantly strengthen many compositions by zooming in as much as your lenses allow or, if possible, getting closer to your subject. Photographic compositions are weakened when important subject matter is too small to see.

CONSIDER VERTICALS

The length of a frame of 35mm film is 50% greater than its width, so every photo is markedly rectangular, not square. Most people have a pronounced tendency to take far more horizontal photos than verticals. But many landscapes have strong

These photos illustrate the option of horizontal or vertical composition that you face in every photographic situation. Which one do you prefer? Notice how the graceful S-curve of the river draws you into the scene. (Rocky Mountain National Park, CO; September; 28mm lens; Fujichrome 100)

vertical elements such as trees, mountains and waterfalls. Also, depending on your perspective, even horizontal landscape features can appear vertical. If you are standing high on a bridge and looking up a river, the river will appear as a vertical element in your photo. And in close-up photography, the stem of a wildflower or a blade of grass can be a strong vertical element.

Consider whether a vertical or a horizontal composition will be most attractive in each situation. You can enliven your nature photography if you consciously take more verticals!

◀ FIND LINES

You see lines almost anywhere you point your camera. How can you use these lines to enhance your photos? Three elements to look for in your photo compositions are diagonal lines, leading lines and curved lines. Judicious placement of these lines can create memorable images.

Horizontal and vertical lines in photos often frame the scene or create visual boundaries within the image. Horizontal and vertical lines characteristically have a static appearance in nature photos, whereas diagonal lines frequently are where the action is. Diagonals are dynamic!

One type of diagonal line is known as a "leading line." A leading line may extend

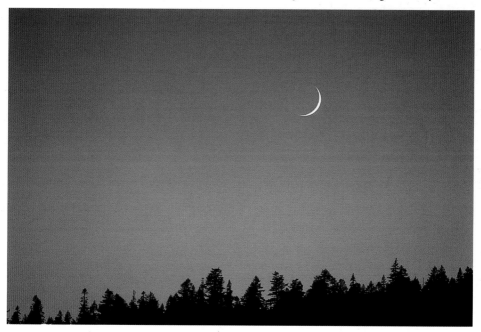

The rule of thirds is a simple guideline to encourage you to position important photographic subjects, such as the crescent moon in this image, away from the center of the composition to heighten visual appeal. (Winema National Forest, OR; July; 75–300mm zoom; Fujichrome Sensia 100)

Facing Page: *This ultrawide-angle photo was composed so that the trunks of old-growth Sitka spruce serve as diagonals to lead the viewer's eye upward. One of the trees blocks the sun, preventing it from overpowering the image. (Oswald West State Park, OR; September; 17mm lens; Fujichrome Sensia 100)*

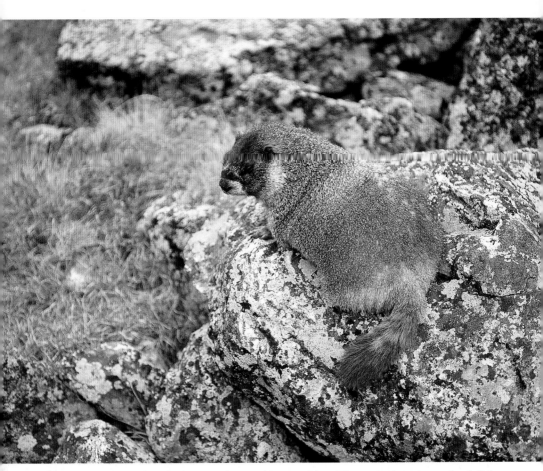

Texture is an often-overlooked element of photographic composition. The contrasting textures of rock, lichen, fur and grass are prominent in this close-range marmot portrait. (Rocky Mountain National Park, CO; August; medium-format camera with 135mm lens; Fujichrome Provia 100)

from the proximity of any of the four corners of a photo toward the middle of the image or toward a significant feature in the image. You can find many leading lines in the landscape such as riverbanks, borders between field and forest, and fallen trees. A leading line often enhances a photo because it leads the viewer's eye into the picture; it visually links the foreground and background, creating continuity and an added element of depth.

Curved lines add aesthetic appeal to nature photos. In particular, S-curves fre-quently appear beautiful to the eye. S-curves in nature include winding rivers, curled tree branches, sinuous vines, swirling clouds, and slithering snakes.

PLACE SUBJECTS OFF-CENTER

Many people routinely compose photos with the main subject in the middle of the image. This approach produces a lot of photos that look rather static as if they were studio portraits. You can often pro-duce a more interesting image by placing the main subject somewhere other than

the center of the image. An easy way to keep this in mind is to use "the rule of thirds." Imagine the scene in your viewfinder is divided into thirds both horizontally and vertically. To visualize this, pretend that a tic-tac-toe grid has been superimposed on the scene. Now compose the image so that the main subject of the photo is located approximately at one of the intersections of these imaginary "thirds" lines.

For instance, if a deer is the main subject of your photo, you might compose the image so that the deer is one-third of the way up from the bottom of the image and one-third of the way across from the left side of the image. You may also want to place prominent horizontal or vertical lines—such as the horizon or a large tree trunk—approximately one-third of the way from one of the four edges of the image. The objective of this rule is to diversify your compositions by consciously positioning your photo subjects away from the center.

⬧ MAKE THE BEST OF NATURAL LIGHT

The vast majority of nature photography relies solely on ambient light. Learning how to successfully work with a wide array of lighting conditions is among the biggest challenges of nature photography. You will learn through experience to appreciate and creatively work with the direction, quality, strength and color of light.

As for the direction of light, when the sun is at your back and your subjects are frontlit, color and detail stand out, but the overall scene often appears rather flat. In contrast, sidelighting is wonderful for

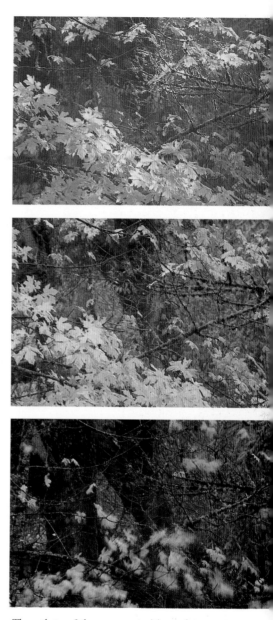

Three photos of the same composition, taken over a four-day period, show how different lighting conditions can change the appearance of a scene. The first image was backlit, the second was made on a cloudy day, and the third was taken at dusk with a 4-sec. exposure to record the remaining leaves dancing in the breeze. (Lewisburg, OR; November; 75–300mm zoom set at 300mm; Kodak Elite Chrome 400; 1/60 sec., 1/30 sec. and 4 sec. @ f/11)

bringing out textures and a sense of depth in photos. Backlighting is terrific for dramatic images. When you photograph strongly backlit subjects, you will typically end up with silhouettes unless you purposely overexpose compared to your meter reading. If you use a point & shoot camera, you can do this by using the camera's backlight compensation feature. However, you may prefer silhouettes in backlit nature situations; try it both ways and see what looks best.

Though some people put their cameras away on cloudy days, the soft light of an overcast day is a favorite of many professionals! Direct sunlight can be harsh and contrasty, but cloudy days reduce contrast, which makes optimum exposures easier to judge. The colors of flowers and foliage may also appear richer under the diffused light of an overcast sky.

◀ TRY A TRIPOD

If you truly want to produce well composed photos, use a tripod! A tripod is regarded by most nature photo pros as a necessity. Why? Because a tripod will force you to slow down. With a tripod, you will spend more time as you set up for each exposure, and you will compose more carefully. As a beneficial side effect, when you use a tripod and move more slowly, your eyes and other senses will open up to nature, and you will literally see more interesting photo subjects. Nature will begin to "happen" all around you as your sensory awareness of nature blossoms! The fact that a tripod also gives you the practical advantage of holding the camera steady during long exposures—a second, a minute or even an hour—is simply icing on the cake!

Focusing

◢ AUTOFOCUSING

Both SLRs and point & shoot cameras have sophisticated autofocus systems. You can produce better nature photos by learning to make the best use of your camera's autofocus capabilities. Check your camera owner's manual to learn where your camera autofocuses. Many cameras autofocus on a small area at the center of the viewfinder; this is usually denoted by a set of brackets ([]) or a rectangle. Some cameras autofocus on several such points, for example, five rectangles in a row across the center of the viewfinder. Your camera may even give you control over which of several autofocusing points to use.

Both SLRs and point & shoot cameras have sophisticated autofocus systems.

Your autofocus camera actually focuses when you push down the shutter release halfway. Many cameras have a focus-confirmation signal to show they have successfully focused; for example, some have a steady green light visible in the viewfinder. If you activate the autofocus, but do not receive your focus-confirmation signal, you are probably trying to get your camera to do something it cannot do. For instance, if you try to autofocus on a flower two inches from your lens, you are far too close. If you took a picture in such a position, the flower would be badly blurred. Assuming your camera autofocuses on a single central point, be sure to put the main subject of your photo—or another object at the same distance from you as the subject—at the center of the image when you activate the autofocus so that your subject will appear in focus.

Pre-Focusing. Fortunately, autofocus SLRs and most point & shoot cameras have a pre-focusing, or "focus-lock," capability that allows you to autofocus on your subject then recompose. When you push the shutter release down approximately halfway (not so far down as to take a picture!), the camera autofocuses and remains focused until you take your finger off the shutter release.

If you have an SLR, you will need to set your camera on the appropriate autofocus mode (often called the "one-shot" mode) to do this; check your owner's manual for instructions. If you have a point & shoot, the focus-lock

Whether you use an SLR or a point & shoot for close-ups, check to see that your camera displays its focus-confirmation signal, which indicates that it has successfully focused. (Humboldt Redwoods State Park, CA; March; 28–85mm zoom; Kodachrome 25; 11 sec. @ f/22)

feature probably requires no special camera setting.

To use pre-focusing, (1) center your subject in your viewfinder, (2) push the shutter release down halfway and check the focus-confirmation light, then (3) while still holding the shutter release halfway down, recompose your photograph for the best composition, and (4) take the photo. This technique is easy once you do it a few times, and it can improve the majority of your photos because it frees you to create interesting

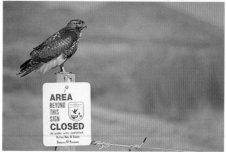

The pre-focusing technique allows you to use auto-focus even when your composition dictates placing the main subject—such as this hawk alertly guarding a wildlife refuge—away from the center of the image. (Bosque del Apache National Wildlife Refuge, NM; December; 75–300mm zoom; Fujichrome 50)

compositions with the subject off-center, while ensuring that the subject is still in sharp focus.

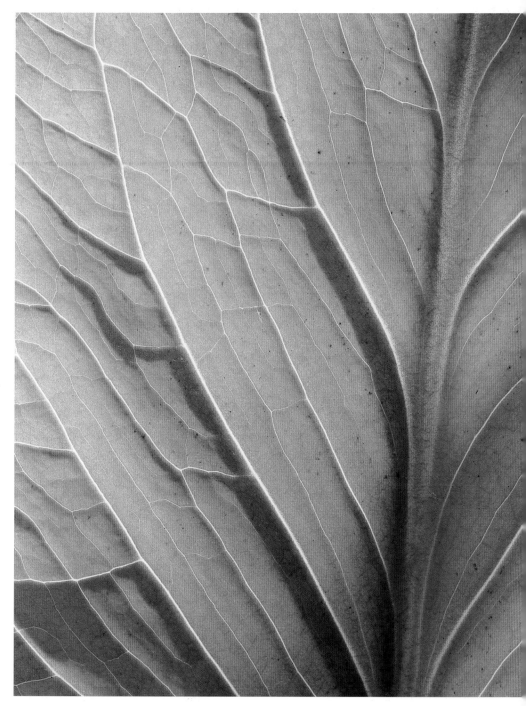

Accurate focusing is absolutely critical in close-up photography. The strong oblique backlighting of a spring morning brought out the intricate veins in this skunk cabbage leaf. (James Baird State Park, NY; May; medium-format camera with 135mm lens; Kodak Ektachrome 100)

When you manually focus with a zoom lens, your focusing will be most accurate if you zoom to the longest focal length to focus, then return to the focal length that produces the best composition before taking the photo. (Kalmiopsis Wilderness, Siskiyou National Forest, OR; May; 28–200mm zoom set at 135mm; Fujichrome Provia 100F; ¹⁄₆₀ sec. @ f/13)

Infinity Lock. Many point & shoot cameras have an infinity-lock (or "infinity focus") feature. When you activate this feature by pushing an infinity-lock button or by selecting your camera's infinity mode, your camera will autofocus at infinity; that is, far, far away! This feature ensures that the camera focuses at infinity when it might not otherwise do so. In some cases, your autofocus system gets confused about your photographic intentions and does not know where to focus when it does not "see" any detail (lines, textures, shapes, patterns) in the center of the viewfinder. This may happen when

you photograph a relatively featureless sky. Or if you photograph a landscape through a window, your camera may mistakenly autofocus on reflections in the window rather than on the scene outside. If you use the infinity lock, your camera will correctly focus at infinity.

⚜ MANUAL FOCUSING

If you have a recent 35mm SLR, then you probably have the option of either autofocusing or manually focusing. If you have an older (pre-1985) 35mm SLR, then you must manually focus. When you manually focus, consider what is the most important

point in the scene to get absolutely sharp. Then take your time and carefully focus.

If you are manually focusing with a zoom lens, you can usually focus much more accurately by setting the lens to its longest focal length. Once you have composed your photo, zoom to your longest focal length (for example, 80mm on a 28–80mm zoom lens) and focus on the main subject, then zoom back to the focal length at which you want to take the picture, recompose, and take the photo.

Also, if you manually focus an auto-focus SLR, you can use your camera's autofocus capability as an electronic rangefinder to check if your subject is in focus. Even when set on the manual focusing mode, many autofocus SLRs illuminate a focus-confirmation light when the lens is correctly focused. This is especially useful when you have difficulty seeing your subject well, such as when you use long telephoto lenses to photograph wildlife in low light.

CHAPTER SEVEN

Landscape Photography

◄ FRAME THE SCENE

How should you compose a particular landscape in your camera's viewfinder? Start by identifying what is most visually appealing to you; think about why you are drawn to this particular landscape. Then you can frame the scene to empha-size the most important landscape features. By walking to a slightly different vantage point—sometimes just a few feet away—you can often come up with a better composition. Always move around and examine the views.

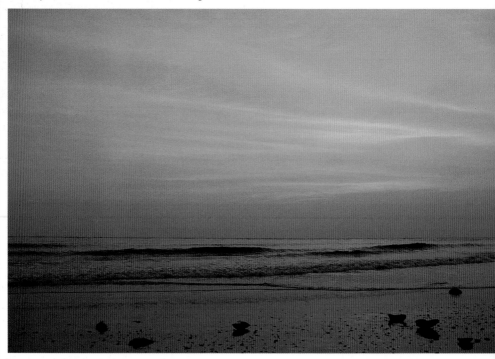

Placement of the horizon one-third of the way up from the bottom of the image provided nice balance in this peaceful image. The horseshoe crabs on the beach, the breaking waves and the softly-lit clouds are all important compositional elements. (Cape May, NJ; September; Kodak Ektachrome 100; 28–70mm zoom lens)

PICK THE RIGHT LENS

Depending on your lens choice, you can photograph landscapes well in a variety of ways. A lot of landscape photography is done with wide-angle lenses, particularly in the 24mm to 35mm range. Short to moderate telephoto lenses, especially focal lengths from 70mm to 135mm, are useful for landscapes that are not so broad, or for taking portraits of landscape features such as a grove of tall trees or a waterfall. And longer telephoto lenses of 200mm or even 300mm give you additional reach to single out and magnify more distant landscape features, for instance, a lone tree on a hill-top. Zoom lenses are excellent because they provide flexibility to crop a landscape in a variety of ways without changing your vantage point.

PLACE THE HORIZON

Inexperienced photographers frequently compose landscapes with the horizon halfway between the top and the bottom of the photo. You can improve your land-scape photos by varying your placement of the horizon. You may create a better composition by placing the horizon near the top or the bottom of the photo, or completely out of the photo. Placing the horizon high in a landscape photo emphasizes the landscape itself, while plac-ing the horizon low emphasizes the sky and gives a greater sense of spaciousness. The key is to consider what works best in each situation.

STRENGTHEN THE FOREGROUND

The visual significance of the foreground is often forgotten in the rush to put a big landscape on film. Use that foreground!

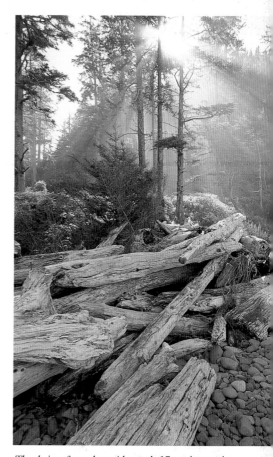

The choice of an ultrawide-angle 17mm lens and a vertical composition made room for the jumble of drift logs that enrich the foreground in this coastal landscape. (Oswald West State Park, OR; September; 17mm lens; Fujichrome Sensia 100)

Strengthen your landscapes by looking for interesting foreground subjects. If the foreground looks weak through the viewfinder, reframe your image or move a short distance for a different perspective with a better foreground. Strong fore-ground elements anchor the viewer's eyes to give a greater sense of depth to a photo.

Good foreground subjects in landscape photos do not need to be large, they sim-ply need enough visual appeal to catch the viewer's eye; this can be done with a

foreground subject that has a striking texture, an unusual shape, or a bright color. You can turn average scenes into superior photos by jazzing up the foreground with eye-catching natural objects such as a patch of wildflowers, fallen leaves or boulders. Good foregrounds are the spice of landscapes!

ADD A HUMAN ELEMENT

Add people to bring your landscape photos to life. People can immeasurably enhance a landscape. Even when they only occupy a tiny portion of a landscape photo, they may be very noticeable to the viewer. Candid photos of people in the landscape often work better than posed shots. If you are patient and keep your camera ready, many such opportunities will present themselves. When your subjects are moving—walking, jogging, skiing, biking—and you are manually setting the exposure, make sure you have ample shutter speed to freeze their motion.

Another consideration is the position of the people within your composition. When people are more centrally located within a scene, they will appear more prominent. Also, keep in mind the level of contrast between your subjects and the background; a red sweater will stand out in the forest far more than green clothing.

LANDSCAPE PHOTO TIPS

Forests. Two complementary strategies for putting forest landscapes on film are the "portrait" approach and the "big-

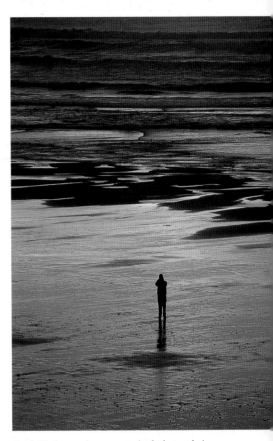

Look for interesting ways to include people in your landscapes. As you compose through the viewfinder, try to find the optimal position of people within the scene. (Roads End State Wayside, OR; January; 75–300mm zoom; Fujichrome Sensia 100)

picture" approach. The portrait approach is an inside view of selected features underneath the forest canopy, while the big-picture approach involves looking at the forest from the outside, that is, from above the treetops.

For the portrait approach, choose a focal length in the short-to-moderate telephoto range between 70mm and 135mm.

Facing Page: Autumn is prime-time for focusing on Eastern forest landscapes. Massive sandstone blocks and a touch of red blueberry leaves in the foreground complement the textured foliage in the background. (Shawangunk Mountains, NY; October; 28–70mm zoom; Fujichrome 50)

Then pan your camera to pick out the most visually interesting subjects within 100 feet of you. For instance, you may choose to focus on the parallel lines of tree trunks that have strikingly colored or textured bark, such as birches, aspens, or ponderosa pines. Or you may frame a forest portrait of a shaft of sunlight that brightly illuminates a patch of ferns or mushrooms within the shaded confines of the forest.

For the big-picture approach, find a vantage point with a sweeping view of the forest—typically an overlook, ridge top or mountain summit—and use a wide-angle lens. Pay special attention to horizon placement; to emphasize the forest, place the horizon near the top of the image or out of the image altogether. When you photograph a forest in hilly or mountainous terrain, try using vertical compositions to show the range of elevations in the landscape.

Wetlands. Marshes, swamps and bogs are excellent photo subjects. Wetlands are chock-full of wildlife, particularly birds and amphibians. Be in place to photograph at dawn and dusk, when animals are active and slanting sunlight accents the natural beauty of wetlands. Wetlands are flat and are usually viewed from ground level, so if you find a higher vantage point, such as a nearby hill or observation tower, you can frequently produce more interesting photos. Make good use of reflections, prominent textures, repeating patterns, and strong lines such as shorelines or boundaries between marsh and forest.

Snowy Scenes. Landscapes covered by snow or ice characteristically have pronounced textures, interesting patterns,

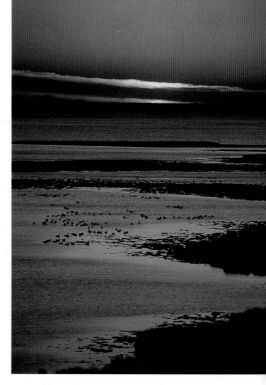

A high vantage point—a birding observation tower—afforded an aerial perspective to this twilight photo of a winter marsh. (Blackwater National Wildlife Refuge, MD; January; 70–210mm zoom lens; Kodachrome 25)

and—if the scene is well lit—strong contrasts between light and dark. Some of the best photo opportunities are immediately after a heavy snowfall or an ice storm.

Snowy landscapes are problematic in terms of exposure. As described in chapter 4, your camera's exposure meter works fine when the scene you are photographing is largely made up of middle tones, intermediate between black and white. In the case of a sunlit, snow-covered landscape, the average tone of the landscape is far lighter than a medium gray. Consequently, photos of bright snowy

landscapes often come out underexposed compared to the actual scene.

When you photograph snowy landscapes—especially if you use slide film—apply the previously mentioned adage, "add light to light." If your camera has manual exposure control, overexpose between $\frac{1}{2}$ and two stops compared to the reading your exposure meter indicates. If you have a point & shoot camera, then you can use the camera's backlight compensation feature to lighten up your images. You can also photograph snowy scenics on overcast days or in low-light situations where there is less contrast in the scene and the exposure is less problematic.

Seascapes. There are two nearly opposite moods that landscape photographers seek to bring out when they compose seascapes. One approach to is to focus on the serenity of a calm day at a wide, sandy beach. Look for simplicity in composition.

This sunlit, snowy Rocky Mountain scene had an average tone much lighter than a medium gray. To get the snow to come out white, not gray, the photo was purposely overexposed by one stop compared to the camera's exposure meter reading. (Rocky Mountain National Park, CO; September; medium-format camera with 135mm lens; Fujichrome 100)

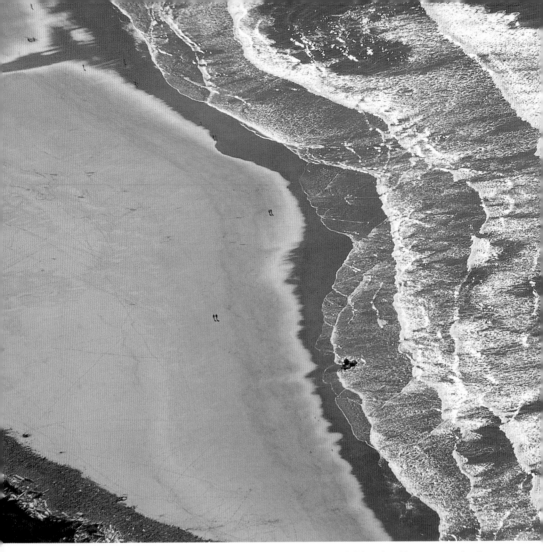

This alternative approach to coastal landscape photography was provided by a hawk's-eye perspective from a mountain ridge 1600 feet above the shoreline. A polarizing filter helped tone down bright reflections from the surf. (View from Neahkahnie Mountain, OR; October; 28–200mm zoom; Fujichrome 100)

If the horizon is visible in your composition, make certain it appears horizontal in your viewfinder; otherwise your photo will give the odd impression that the ocean is draining downhill to one side of the image! Slow shutter speeds, $\frac{1}{30}$ sec. or longer, are useful to blur and soften the motion of waves.

A second approach is to emphasize the dynamic tension that exists between the land and the irrepressible forces of wind, wave and tide. This approach works well on blustery days along rocky coastlines or on stormy days at the beach. Try to record the energy of big waves as they crash into the shoreline. Look for the "decisive moment"—the climactic instant in which something with high visual interest happens, such as a breaking wave striking a rocky headland. Make dynamic photos in

which the viewer knows the scene lasted for only an instant—the particular instant you preserved on film!

Sunrises and Sunsets. An important consideration for sunrise and sunset photos is the position of the horizon in the photo. To emphasize the sun, brightly lit clouds, and the expansiveness of the sky, place the horizon low. On the other hand, if the landscape has visually appealing elements, for instance, a herd of elk or a carpet of wildflowers, then place the horizon near the top.

Sunrise and sunset exposures are tricky because of the sun's brightness and the contrast between the sky and the darker landscape. A common result is that the sun looks OK in your photo, but the land appears almost black. As in the case of photographing snowy landscapes, it works

Below: Many of the best landscape photo opportunities occur well after sunset. In this scene, the Columbia River took on the pastel hues of the sky at nightfall, and the river's surface was smoothed by a 30-second exposure. The ribbons of light were created by cars and trucks on I-84. (View from Crown Point State Park, OR; August; 75–300mm zoom; Fujichrome Sensia 100)

well to "add light to light." If your camera has manual exposure control, overexpose between 1 and 2 stops compared to your meter reading. The brighter the sun, and the more prominent it is in your composition, the more intentional overexposure you will need. If you have a point & shoot camera, then try the camera's backlight compensation feature to see if you prefer lighter images.

Running and Falling Water. From a location alongside a creek or river, you can make strikingly different photographs by looking upstream, downstream and across the stream. When you are on the banks of a river with riffles or rapids, composing photos of the upstream view is frequently easiest. If a stream is flat and slow-moving, you can often move from the stream bank up to a higher vantage point to find more interesting compositions. When you include a river as an element in a wide-angle landscape, use its linear form to enhance the aesthetics of the landscape; remember that curved or diagonal lines can serve as strong compositional elements.

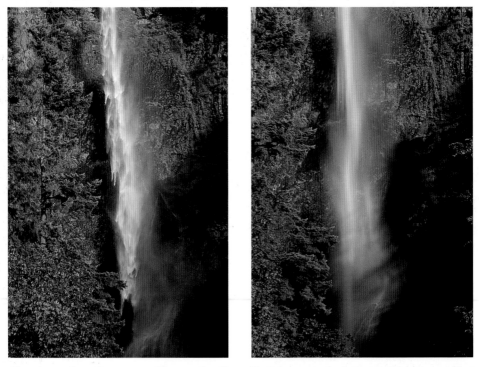

Two photos taken minutes apart illustrate the effects of both shutter speed selection and changing ambient light. A ¹⁄₁₂₅ sec. exposure gave the waterfall in the first photo an appearance similar to what the naked eye sees. A ¹⁄₃ sec. exposure—forty times as long as the first one—smoothed the water's appearance in the second photo; the partial spectrum near the center is from sunlight refracted by the falling water. (Multnomah Falls, Columbia Gorge National Scenic Area, OR; July; 28–200 zoom lens set at 180mm and 200mm; Fujichrome Provia 100F; f/5.6 and f/32)

Facing Page: A canopy of overhanging leaves provides a nice accent for this cross-stream view of white-water riffles. A slow shutter speed recorded the swift motion of the water. (Great Smoky Mountains National Park, NC; June; medium-format camera with 45mm lens; Fujichrome Velvia)

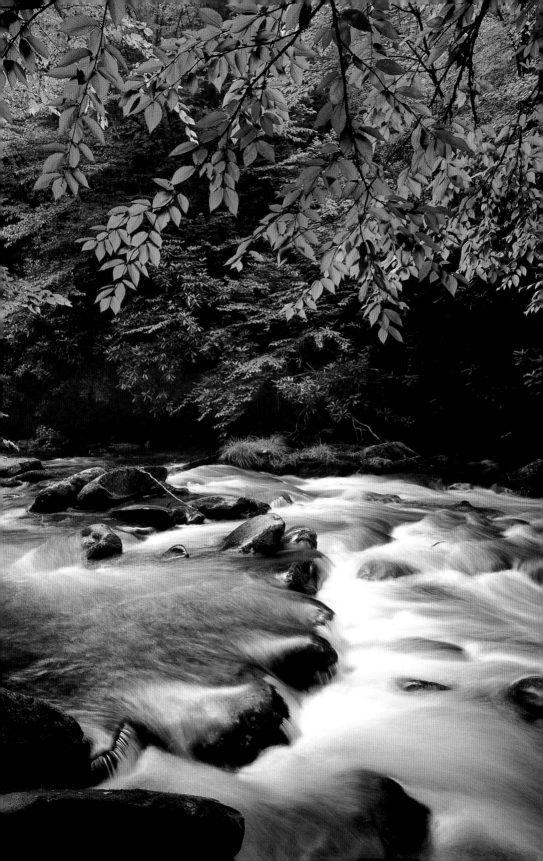

As you photograph waterfalls, look for alternatives to the standard, head-on view. Walk around and check different perspectives through your viewfinder. You may want to zoom in or move closer and just show a portion of the falls. Make sure that the water appears to be falling vertically in your waterfall compositions, unless you desire an abstract effect.

How a waterfall appears in a photo greatly depends on your choice of shutter speed. If you can manually set shutter speeds on your camera, use shutter speeds of $1/500$ sec. or faster to freeze the motion of falling water. Shutter speeds of $1/15$ sec. or slower tend to give the falling water a silky, "cotton-candy" look. The longer the exposure, the more pronounced is this silky smoothing of the falls.

Even if you use a point & shoot camera, you have some control over the way your waterfall photos will appear. When you photograph bright scenes—such as a sun-lit waterfall on a summer day—with fast film (ISO 400, for example), your camera will choose a fast shutter speed that will likely freeze the water motion. But if you are photographing scenes in low light with slower film (ISO 100, for example), then your camera will select a slow shutter speed that may give the falling water a silky appearance. If a slow shutter speed is your goal, then set your point & shoot to its "flash-off" mode.

Aerials. You can take excellent aerial landscape photos by following a few guidelines. To photograph on a commer-

cial flight, request a window seat that is well in front of or well behind the wing. In flight you are moving very fast, often 500 mph or more, so slow shutter speeds will result in blurry pictures. If you are manually setting exposures, select $1/250$ sec. or faster when possible. Use medium-to-high speed films, ISO 200 or 400, unless the lighting is extremely bright. For the best light, fly quite early or quite late in the day.

For sharp photos, try to photograph at relatively low altitudes soon after take-off.

For sharp photos, try to photograph at relatively low altitudes soon after take-off or shortly before landing. Line up your camera with the front element of your lens parallel to the window. Place the lens as close to the window as you can—flush is best—to avoid picking up reflections on the inside of the window. Do not use flash; it will be reflected by the window, and will surely not light up the earth! If your camera automatically activates your built-in flash, use your "flash-off" mode to override it.

Facing Page: This monochromatic aerial photo relies on low-angle winter sunlight to accentuate a series of snowy mountain ridges. Look for opportunities to photograph at lower altitudes within 20 minutes of take-off or landing when landforms will appear more distinct. (Utah; December; 28–70mm lens; Fujichrome 100)

Close-up Photography

GET CLOSE!

The secret to good close-up photography is—no surprise!—to get close to your photo subjects. A common beginner's mistake is to photograph flowers and other small objects from such close range that the lens cannot focus; the result is a blurred photo. Each photographic lens, just like your own eyes, has a minimum distance at which it can focus. Thus an important first step is to find out the minimum focusing distance of your lenses. The distance scale on the top side of an SLR lens shows the minimum focusing distance; it is the smallest number listed.

A meaningful way to physically determine the minimum focusing distance of your point & shoot camera or SLR lenses is to choose a stationary object such as a flower or a tree trunk. Stand about six feet away from the object and focus on it, then slowly move closer until you can no longer focus. If you have an SLR, you can tell you are too close to focus when the image in the viewfinder is blurred even with the lens manually set at the minimum focusing distance. For SLR lenses, minimum focusing distance varies from less than one foot to more than six feet. If you have a point & shoot camera, you can usually tell when you are too close to focus because the focus-confirmation light does not come on in your viewfinder when you depress the shutter release halfway to activate the autofocus. The minimum focusing distance of most point & shoot cameras is in the range of two to four feet.

The viewfinder on a point & shoot is separate from the lens; when you look through the viewfinder, you are not viewing through the lens as on an SLR. Thus your close-up subjects may appear in focus to you, but may be far too close for your lens to focus. Also, because of the separation of the viewfinder and lens, at close focusing distances there is a difference between the image the camera "sees" and the image you see. Follow the guidelines in your point & shoot owner's manual to use special close-up frame lines in your viewfinder to compose close-ups.

Facing Page: For strong close-up compositions of flowers, position your camera low to the ground and move in close to your subject. This foxglove is nicely accented by raindrops; some close-up photographers carry a small plastic spray bottle to produce this effect. (Tillamook State Forest, OR; July; 28–200mm zoom lens; Agfachrome RSX 50)

A macro lens produced this life-size reproduction of a rose. For intense color, photograph flowers on overcast days. (Jackson County, NC; May; Tamron 90mm macro lens; Fujichrome 100)

◢ CONSIDER MACRO GEAR

If you have an SLR, then consider using special equipment to do close-up photography such as a macro lens, supplementary close-up lenses, or extension tubes. Close-up photography is referred to as macro photography. A macro lens can focus so closely to your subjects that you can produce photos of your subjects that are at least half life-size (1:2 ratio) on the slide or negative. For example, if you photograph a flower with a 2" diameter, then the flower's image is reproduced 1" in diameter on the slide or negative, and it fills up the full width of the photo. The most popular macro lenses have a focal length of approximately 50mm or approximately 100mm; some of these lenses can focus on subjects at life-size (1:1 ratio). Many professional nature photographers prefer macro lenses that are approximately 100mm, because these lenses allow greater working distance and have a narrower angle of view, which can simplify composition. Macro lenses range in price from $200 to more than $500.

A lot of zoom lenses are loosely marketed as "macro zooms," but do not provide true macro performance. Less than 5% of the 250+ zoom lenses currently on the market have the close-focusing ability to reproduce subjects at one-half life-size.

Before you purchase a zoom lens for close-up photography, try it out and see how close it will focus.

For SLR camera users, an inexpensive alternative to a macro lens is a supplementary close-up lens, which some people call a "diopter." It looks like a clear filter and screws on to the front of your lenses. It reduces the minimum focusing distance of the lens to which you attach it. Supplementary close-up lenses are often sold in sets of three and have varying strengths identified as +1, +2, +3, +4 and so on. For example, a +4 will allow you to focus closer than a +3, which in turn allows you to focus closer than a +2. You can simultaneously attach two or more supplementary close-up lenses to your lens, which allows you to focus even closer, but doing so can noticeably degrade image quality. Use of only one supplementary close-up lens at a time is recommended, unless you absolutely must focus closer to your subject. Sets of three diopters range in price from $35 to more than $75.

Extension tubes are another relatively inexpensive accessory for close-up photography. These are hollow plastic or metal cylinders that you mount between your camera and lens. Extension tubes reduce the minimum focusing distance of any lens to which they are attached. They cost $60 and up, and are sold individually or in sets of three of various lengths; you can attach one, two or three at a time. The more extension, the closer your lens can focus to your subject, hence the larger you can reproduce your subjects on film. Unlike multiple supplementary close-up lenses, extension tubes do not degrade your image quality. If you shop for extension

The first photo, taken at the minimum focusing distance of a 75–300mm zoom lens, shows the flowers at one-fourth life-size on the film. For the second photo, a +3 supplementary close-up lens was attached to the zoom lens; this reduced the minimum focusing distance to the point that the trillium was reproduced at life-size on the film. (Gifford Pinchot National Forest, WA; May; 75–300mm zoom set at 300mm; Fujichrome Sensia 100)

tubes, check to see what degree of compatibility they have with your camera's electronic features.

DEPTH OF FIELD

Depth of field is extremely important in close-up photography. Why? Because when you focus on subjects very close to your camera, depth of field is minimal. The closer you focus, the less depth of

field you have. The zone of sharpness in a truly close-up photo may only extend from a fraction of an inch in front of the subject on which you are focused to a fraction of an inch in back of the subject. For example, if you set a 100mm macro lens on f/4 and focus on a flower two feet away, less than 1/3" of the flower will be in sharp focus.

Since depth of field is limited in close-up photography, accurate focusing is critical. For sharp close-up photos, follow these three guidelines:

1. Focus precisely on the most important part of your subject.

2. Make the camera as stable as possible. Use a tripod for close-up photography whenever possible!

3. Remember that you can enlarge depth of field and thus get more of your subject in focus by using a smaller aperture. In the example above, an aperture of f/22 would more than quadruple the depth of field at f/4.

◢ SQUARE UP TO YOUR SUBJECTS

Given the very limited depth of field in close-up photo situations, a useful technique is to line up your camera so that your lens is almost equidistant from each

Depth of field is so minimal when you get very close to small subjects that focusing must be absolutely precise. Use a tripod whenever possible for sharp close-up photos. (Jackson County, NC; June; 28–200mm zoom set at 135mm with +5 supplementary close-up lens; Fujichrome Sensia 100; 1/30 sec. @ f/6.7)

If you line up the front of your lens parallel to a spider web—in other words, with the barrel of the lens pointing at a right angle to the plane of the web—you can maximize the amount of the web that will appear in focus. (Benton County, OR; September; 28–200mm zoom set at 200mm; Fujichrome Sensia 100; 1/125 sec. @ f/5.6)

of the important subjects in your photo. To visualize this, think of aligning your camera so that the front of your lens is parallel to the most important plane (two-dimensional surface) in the close-up scene you want to photograph. This technique maximizes the amount of the image that will appear in focus.

⚜ USE FLASH

Though most nature photography is done with ambient (naturally available) light, flash can often enhance close-up photographs. Flash is used for close-ups in situations where light levels are too low to photograph without flash. Flash is also valuable when used for "fill-in" light and to brighten subjects in shaded areas of a close-up composition.

The combination of flash and grainy high-speed film gave this daffodil a soft, textured look. (Shenandoah County, VA; April; 70–210mm zoom set at 210mm with +3 supplementary close-up lens; Scotch Chrome 1000; 1.5 sec. @ f/32)

To find compelling close-up photo subjects, look downward; you will often find beautiful things! Then move in close and compose carefully. (Bald Eagle State Forest, PA; October; 28–200mm zoom; Fujichrome 100)

Facing Page: These tupelo leaves were photographed in very low light within an oak forest. The camera's flash lit up the leaves while leaving the background black. (George Washington National Forest, VA; September; point & shoot camera with 38–80mm zoom set at 80mm; Fujichrome 100)

Excellent close-up photo opportunities can be found in city parks and private gardens. Oblique backlighting brought out the translucence of the greenery to complement these yellow irises. (Washington County, OR; May; point & shoot camera with 28–56mm zoom; Fujichrome Sensia 100)

Be careful not to overpower your close-up subjects with flash. Too much flash may overexpose your subjects. Most flash units, as well as some built-in flashes on SLRs and point & shoot cameras, give you the option of reducing your flash's output.

Your owner's manual contains valuable information on various flash modes and on the effective distance range of your flash. Try out your flash's modes and settings in a variety of situations with various subject-to-camera distances; write down what you

card up to the size of a poster, with aluminum foil. Thoroughly crumple the foil—the creases in the foil will soften the reflected light—then straighten it out prior to taping or stapling it to the cardboard. A simpler variation is to skip the cardboard, and just carry folded or rolled sheets of aluminum foil into the field; these are also useful for baking potatoes in the campfire! Your reflectors can be balanced in a bush or in high grass, propped against a tree trunk, or even suspended by bungee cords from low branches.

These foil reflectors are useful to bounce natural light exactly where you want it in close-ups. For instance, if you photograph wildflowers in a dense forest on an overcast day, minimal ambient light may reach the flowers. You can position one or more foil reflectors on the ground or in underbrush near the flowers (always making sure the reflectors are not in the image!) at an angle so that the foil bounces light from the sky onto your photo subjects. This technique often doubles the amount of light on wildflowers.

Another good accessory to reflect light is an auto sunshade made of synthetic fabric attached to a flexible metal frame. These shades usually fold to a small size and spring open to a much larger size such as 24" x 28." They not only keep your parked car cooler on a sunny day, they are also a handy nature photo field accessory! They are inexpensive (often less than $10), lightweight, durable, and come in a variety of colors and sizes. An ideal shade is silver on one side and gold on the other side; the silver side provides "cool" lighting, while the gold side gives a "warmer" cast to your photos.

do on each exposure, then evaluate your results.

◀ CUSTOMIZE LIGHTING

The lighting for close-up photography can often be improved with simple accessories that either reflect or diffuse ambient light. You can make reflectors by covering sheets of cardboard, from the size of an index

A telephoto lens, a short camera-to-subject distance, and a large aperture—f/4—worked in concert to minimize depth of field in this pink dogwood image. (Hoyt Arboretum, Portland, OR; May; medium-format camera with 135mm lens; Fujichrome Velvia; ⅟₆₀ sec. @ f/4)

You can hold or prop these shades in position to bounce skylight onto your close-up photo subjects; alternatively, you can use them to block overly bright, contrasty sunlight. An easy way to diffuse direct sunlight is to block the sun with a light-colored umbrella or pieces of any translucent, light-colored fabric.

⬥ FLOWER PHOTO TIPS

To make the best of wildflower photo opportunities, get to know your local wildflowers. In most temperate regions, the wildflower world is a visual feast of photographic opportunities from early spring to late autumn. Also consider photo opportunities with ornamental flowers, shrubs and blooming trees in lawns, gardens, greenhouses, and city parks.

Murphy's Law is well known to every flower photographer! More often than not, when you find beautiful flowers to photograph, a breeze is blowing and your potential photo subjects won't stand still for a picture! What's a flower photogra-

pher to do? If your camera has manual exposure control, then, when possible, use a shutter speed of $\frac{1}{250}$ sec. or faster to freeze the motion of moving flowers. You can also use one or more of the following techniques to increase the probability of sharply focused flower photos in a moving-flower situation:

1. Shield the flowers from the breeze with your body, a friend, a windbreaker or a tarp.
2. Use high-speed film—ISO 400 or 800—so that faster shutter speeds are possible.
3. Use one of the reflectors mentioned in the previous section to bounce more natural light onto the flowers.
4. Use a flash.
5. If all else fails, be patient—that bothersome breeze will eventually stop!

An easy way to enhance many flower photos is to position your camera near the ground. Setting up your camera as low as you can on your tripod, or handholding the camera while you lay flat on the ground, will provide a more interesting perspective. To create eye-catching compositions, get down so low that you are looking up at the flowers with the sky in the background.

OTHER CLOSE-UP SUBJECTS

Nature is full of small objects that have visually appealing textures, curious patterns and striking color combinations when viewed from close range. Seed pods, cones, berries, tree bark, mosses, mushrooms, lichens, rocks, and fallen leaves are superb close-up photo subjects. The ever-changing ripple marks in the sand of dunes, beaches and stream banks are another favorite subject for stunning close-up photos. If you get close enough, you can produce wonderful images of each of these subjects.

Wildlife Photography

◢ GET TO KNOW THE ANIMALS

To successfully photograph wildlife, learn all you can about your animal photo subjects. Find out what habitats they prefer for feeding and cover. Learn their daily and seasonal activity patterns. Find out what their vocalizations and other behaviors mean. Study the acuity of their senses of sight, hearing and smell. Find out what kinds of tracks and other signs they leave behind. And, most importantly, learn to what degree they will tolerate human intrusions, and whether your presence is potentially harmful to them— or to you!

The best way to learn about your photo subjects is to observe them in the wild. Professional nature photographers spend literally hundreds of hours closely observing the animals they photograph.

Look for opportunities to photograph groups of animals. A zoom lens that extends to 300mm is very useful, especially if you like to photograph birds. (Fernhill Wetlands, Forest Grove, OR; March; 75–300mm zoom set at 300mm; Fujichrome Provia 100F; ¹/₂₅₀ sec. @ f/5.6)

There is no better place to practice animal photography than in your backyard and local parks. Animals that are accustomed to people are far easier to work with as a beginning photographer. (Blacksburg, VA; June; 70–210mm zoom; Kodachrome 25)

A magazine cover photo often is the product of months of field photography.

USE LONG LENSES

Wildlife photography is the branch of nature photography in which you will most often use the longest focal lengths you have; a point & shoot that zooms to more than 100mm or an SLR with a zoom lens that extends to at least 200mm is a good starting point. If you are passionate about wildlife photography, a 70–300mm zoom lens is a useful acquisition.

Remember that depth of field is dependent on the focal length of your lens. The longer the focal length of the lens, the smaller the depth of field. Thus precise focusing is critical when you use long telephoto lenses. Also, long telephoto lenses are comparatively heavy and often difficult to hold steadily. So for sharp photos with lenses of 300mm or longer, use a tripod whenever possible.

Teleconverters—supplementary lenses that you mount between your camera and a telephoto lens—are useful for wildlife photography. They increase the effective focal length of the lens; a 1.4X teleconverter increases the focal length by 40%, and a 2X teleconverter doubles the focal length. Teleconverters have two notable drawbacks: (1) They may noticeably

degrade image quality, and (2) they always significantly reduce the light-gathering ability of your lenses. A 1.4X teleconverter reduces lens speed by one stop, while a 2X teleconverter costs you two stops of lens speed. Thus a 300mm f/4 lens attached to a 1.4X teleconverter effectively functions as a 420mm f/5.6 lens; the same lens attached to a 2X teleconverter functions as a 600mm f/8 lens. Teleconverters are best when used on single-focal-length telephoto lenses with a maximum aperture of f/4 or faster. When used with moderate-priced zoom lenses, teleconverters may cause loss of autofocusing capability and a significant reduction in image quality.

PHOTOGRAPH WHERE YOU LIVE

The best location to develop your wildlife photo skills is where you live. In terms of learning nature photography, there is no place like home! Photo skills you develop in your backyard or your local parks are transferable to wildlife-rich national parks and wildlife refuges. If you consistently make good photos of neighborhood squirrels and songbirds, you will have a greater chance of success when you get opportunities to photograph rare or exotic animals in wild places.

•

PHOTOGRAPH EARLY AND LATE

More outstanding wildlife photographs are taken within a few hours of sunrise and sunset than at any other time. This is partly because so many animals are active and visible at either end of the day. The warm

Much of the joy of nature photography is found in the times spent in wild places observing wild animals. If you spend a significant amount of time photographing a particular species, you will begin to observe and photograph interesting gestures and behaviors. (Shenandoah National Park, VA; May; 70–210mm zoom; Fujichrome 100; ½₅₀ sec. @ f/5.6)

light and long shadows of early morning and late afternoon are also conducive to attractive photos. Conversely, the middle of the day, especially in summer, usually offers less interesting lighting and much less wildlife activity. Midday is an excellent time to catch up on the sleep you missed when you got up to photograph animals at dawn!

Facing Page: The transitions between day and night are ideal times to photograph wildlife. Be in the right place, have your camera ready and make sure you have plenty of film and plenty of patience! (Bosque del Apache National Wildlife Refuge, NM; December; 28–70mm zoom; Fujichrome 50)

BE PATIENT

Take your time! Every wildlife photographer quickly learns that nature is not a vending machine; you cannot make it "happen" on command. Nature always moves at its own pace. Great wildlife photography takes great patience. To find and photograph the truly extraordinary moments in nature takes a lot of time. Wonderful opportunities are available to the photographer who is in the right place at the right time. You simply have to be there!

FEED WILDLIFE?

To feed wildlife for the sake of attracting animals to photograph is a bad idea, with the sole exception of a permanent, well-maintained backyard bird feeding station. Baiting wild animals, particularly in residential and park areas, has detrimental consequences:

1. Animals can develop an increased dependence on people for food, along with a markedly decreased ability to survive in the wild.
2. Animals that live on people food can become malnourished. This is frequently the case with ducks and geese that subsist on human handouts in municipal park ponds, rather than on a far more nutritious natural diet.

Look for interesting interactions between animals. Notice how you are drawn to the sharply focused eyes of these ground squirrels; the limited depth of field helps reduce visual distractions. (Cedar Breaks National Monument, UT; August; 75–300mm zoom; Fujichrome 100)

To photograph uncommon wildlife, such as the threatened spotted owl of the Pacific Northwest's old-growth forests, requires patience, perseverance, and special care so that you do not become another stress on the animals you photograph. (Gifford Pinchot National Forest, WA; May; 28–200mm zoom set at 200mm; Fujichrome 100)

3. Wild animals that learn to get food from humans may exhibit aggressive behavior toward people and pets with unfortunate results. "Panhandling" animals that hang around backyards and city parks can also carry serious diseases such as rabies.

Please remember that wild animals by definition are not domesticated animals. Rely on your knowledge of animals and your patience—not on potato chips and moldy bread—to get superb wildlife photos!

◀ WILDLIFE PHOTO TIPS

Nature photographers have a wide range of favorite animal photo subjects. Specific wildlife photo subjects require special techniques as described in the following sections.

Large Mammals. Judging by how frequently various types of wildlife appear on the covers of magazines and coffee-table photo books, large mammals—such as deer, elk, bears, and bighorn sheep—are among the most popular photo subjects. Two inherent advantages of photographing large mammals are that the animals are big enough that you do not have to be exceptionally close to photograph them, and you do not necessarily need a long telephoto lens to get a good photo.

One essential feature for a good photo of a large mammal is that at least one of the animal's eyes is readily visible and in sharp focus. Why? Because when we see a large animal in real life or in a photo, we

immediately look to the animal's eyes, similar to the way we establish eye contact with other people. So try to always get an unobstructed view of at least one eye. A well-lit eye is preferable to one in deep shade. Make sure that the eye is sharply focused. If you are using a point & shoot camera, this is an ideal situation to use the pre-focusing technique that was explained in chapter 6.

Strive for candid wildlife photos in which the animals exhibit their normal behavior . . .

When you photograph large mammals, reach beyond the cliché of animal portraits that appear to be posed, with a wary-looking animal standing stiffly at attention. Strive for candid wildlife photos in which the animals exhibit their normal behavior rather than a reaction to a noisy photographer. If the animals are aware of your presence, then be absolutely still, and allow plenty of time for them to become accustomed to you. Animals frequently will ascertain that you are not a threat, and they will resume their everyday behavior.

Small Mammals. Small, furry creatures—including squirrels, rabbits, groundhogs, and chipmunks—are frequently present in residential areas and local parks. Many of them are surprisingly approachable and even gregarious around nature photographers. Keep in mind that these animals often appear smaller than you anticipate in your photos. Either you need to use at least a moderate-length telephoto lens, 135mm or longer, or you need to be quite close to the animals. You can accentuate the apparent size of small mammals by photographing them from a very low camera position.

One of the pronounced traits of many small mammals is that they must move quickly to escape predators. If they feel threatened by your approach, they will immediately either run to dense cover, go to a nearby burrow or climb a tree far out of reach. Thus you need to learn the "safety distance" of each species; in other words, how close you can be before the animal will react by moving to safety. You will get many of your best photos by operating just beyond that distance.

To freeze the rapid motion of small mammals often requires shutter speeds of $\frac{1}{125}$ sec. or faster; this depends on the animal's speed, your focal length, and how close you are to the animal. With a point & shoot camera, you cannot manually set shutter speeds, but you can use high-speed film (ISO 400 or ISO 800) so that your camera will automatically select faster shutter speeds.

Itty-Bitty Creatures. Excellent miniature photo subjects include frogs, lizards, butterflies, moths, spiders, ants, bees, caterpillars, and even slugs! These little creatures are among the most photogenic; they often display brilliant coloration, striking patterns, or intricate camouflage. These small wonders are accessible in local parks and backyards—too accessible it seems, when you find them living in your house!

An overriding concern for successful photography of very small animals is to get extremely close—often as close as your lens allows. A good strategy is to start ten to fifteen feet away from little creatures, then slowly creep closer. If you use a point

Move as close as you can—very slowly!—to photograph small animals like this rough-skinned newt. Aim the camera straight downward and stop the lens down to the smallest aperture—f/27, in this case—to maximize the portion of the animal that will appear focused within your limited depth of field. (Tillamook State Forest, OR; March; 28–70mm zoom set at 70mm with +3 supplementary close-up lens; Kodak Elite Chrome 100; 2 sec. @ f/27)

& shoot camera, you will usually want to use the longest focal length of your zoom lens for maximum magnification.

Birds of Prey. The wildness, grace, size and sheer power of eagles, hawks, falcons and owls make them favorites of wildlife photographers. Fortunately for photographers, many birds of prey characteristically spend much of their time sitting almost motionless as they carefully survey their surroundings. For good photos of raptors, get as close as you can without disturbing the bird. How close? This depends on the species, the time of year, the habitat and the individual bird's previous experience with people. Keep in mind that birds of prey are protected under federal law and that many birds of prey, such as the bald eagle, are easily disturbed during the nesting season.

Birds of prey have very regular patterns of hunting and fishing behavior. For example, kestrels hover like feathered helicopters for minutes at a time over grassy areas as they hunt small rodents, and ospreys circle lazily over open water before diving for fish. Once you learn these patterns, you can position yourself to capture the high-speed interactions between raptors and their prey.

Waterfowl. Four factors favor waterfowl as photo subjects: Their comparatively large size, their large populations, their tendency to congregate in large groups, and their tolerance of human presence in many parks and refuges. When photographing waterfowl, nature photographers often use blinds to conceal their presence. A blind is a temporary or permanent camouflaged structure large enough for one or several photographers. Refuges sometimes

Through experience you can learn to follow moving animals through the viewfinder. Try to keep the animal well framed while you also keep the most important part of the animal—the eye in many cases—in focus. (Shenandoah County, VA; June; 75–300mm zoom; Fujichrome 100)

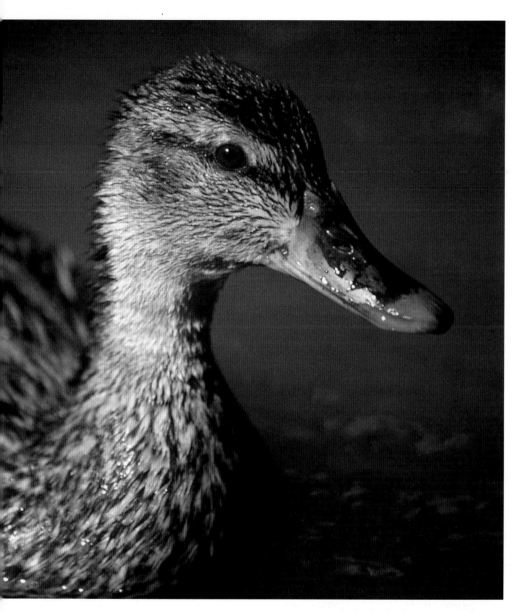

have permanent blinds set up for observation. You can also park near wetlands in many refuges and use your vehicle as a blind; many animals are far less wary of a car or a truck than of a person on foot.

To develop your waterfowl photo skills, you might first photograph slow-moving birds floating on the water. Also practice following the birds in flight through your camera's viewfinder. Learn to anticipate the timing and direction of explosive waterfowl takeoffs and photogenic group landings.

Backyard Birds. Virtually anywhere people live, backyard birds can be found. To improve your photo opportunities, you

can enhance your backyard habitat for songbirds. Techniques range from simply providing a bird feeder, to putting up nest boxes, or landscaping with native shrubs and trees that provide food and cover. Songbirds are very small, so use the longest lens you have and get as close as possible! Use medium to high-speed films, ISO 200 or ISO 400, to freeze the rapid flitting movements of small birds.

Many good backyard bird photos, especially snowy winter portraits, are taken from indoors. You can take excellent bird photos through a living room window. Make sure the window is clean, put the camera very close to the window, line up the camera so that the front of the lens parallels the window, and turn off all indoor lights to reduce reflections. Do not use a flash; the light from a flash would be reflected in the window and would dominate the photo. Depending on the traffic flow inside your home, you might even leave a camera set up on a tripod with a good view of a backyard bird feeder. This increases the chances you will be ready when photo opportunities arise!

Facing Page: A pileated woodpecker is outlined against green leaves and sky. Many photographers are drawn to silhouettes; generally, if a subject appears in silhouette to the naked eye, your camera's metered exposure will give you a silhouette. (White Mountain National Forest, NH; August; 75–300mm zoom set at 300mm; Fujichrome 100)

Glossary

Aperture—The diameter of the lens opening through which light passes to reach the film. Apertures are commonly expressed as f-stops.

Autofocus—An electronic system in most point & shoot and SLR cameras that automatically focuses the lens.

Backlight Compensation—A feature on many point & shoot cameras that is used to produce better exposures in situations where a dark or shaded subject is surrounded by a bright background, as when sunlight is shining on the back side of the subject. This feature purposely overexposes the image compared to the exposure meter reading.

Blind—A camouflaged structure that conceals a photographer and makes it possible to unobtrusively observe and photograph wildlife.

Bracketing—The technique of taking two or more exposures of the same scene with slightly different exposure settings; this is usually done by taking an exposure at the metered exposure setting, then taking additional exposures at other settings varying from one another by half or full stops. Bracketing is often used in difficult or unusual exposure situations.

Composition—The arrangement of all the artistic elements—shape, form, color, tone, pattern, texture, balance and perspective—that make up a photograph.

Depth of field—In a photograph, the zone from near to far that appears in acceptably sharp focus. Depth of field depends on the focal length of the lens, the lens aperture (f-stop) and distance at which the lens is focused.

Depth-of-field preview—A feature on some cameras that lets the photographer actually see the front-to-back zone of sharpness that will appear in a photo.

Exposure—The amount of light that reaches the film. Exposure is determined by the duration and intensity of light striking the film; these two variables are controlled by the shutter speed and aperture respectively.

Exposure latitude—A measure of a film's ability to produce acceptable photos when it is underexposed or overexposed. Color print films generally have much greater exposure latitude than slide films.

Exposure meter—A light-measuring device in the camera that determines how much light is reflected from the

photographic subject and thus how to expose the image. Also known as "light meter" or simply "meter." As a verb, "meter" refers to pointing your camera toward a subject to measure or "read" how much light is reflected from it.

Extension tube—A hollow metal or plastic cylinder that is mounted between the camera and lens to reduce the minimum focusing distance of the lens for close-up photography.

Film speed—A measure of film's sensitivity to light. Film speed is rated on a standard scale known as ISO; for example, an ISO 200 film is twice as light sensitive as an ISO 100 film.

Filter—A supplementary lens attachment that is mounted or screwed onto the front of a lens or mounted on a bracket attached to the lens to enhance photographic images.

Focal length—The distance from the optical center of a lens to the film, measured in millimeters; this is the usual way of identifying lenses.

Focus lock—A common feature on point & shoot and autofocus SLR cameras; when you push the shutter release down approximately halfway, the camera autofocuses and remains focused until you take your finger off the shutter release. This allows you to focus on your subject, then recompose the scene before taking the photo.

F-stop—The standard way of expressing the lens aperture (the diameter of the lens opening); f-stops include f/2.8, f/4, f/5.6, f/8, f/11, f/16, and f/22, where "f" represents the focal length of the lens. Thus, f/2.8 is a compara-tively large lens opening; f/22 is a comparatively small lens opening.

Lens speed—The largest aperture of a particular lens.

Macro lens—A lens designed especially for close-up photography. It can be focused at very short distances from the photographic subject.

Medium format—A film format larger than 35mm, but smaller than large format. Medium-format cameras use 120 or 220 roll film and produce negatives or slides with dimensions such as 6x6cm and 6x7cm.

Minimum focusing distance—The shortest camera-to-subject distance at which a particular lens is capable of focusing.

Overexposure—A photo or a portion of a photo that is too light ("washed out") because the film was exposed to too much light.

Point & shoot camera—A lightweight, compact camera that has a built-in lens and that automatically focuses and sets exposures.

Polarizing filter—A filter that reduces reflections from shiny surfaces, enhances color saturation, and deepens blue skies.

Rule of thirds—A guideline for photo composition that suggests visualizing your viewfinder divided into thirds, then placing the main subject(s) of an image near the intersections of these "thirds" lines.

Self-timer—A delayed exposure feature on nearly all cameras; you push the shutter release and ten seconds (or some other measured time interval) later the camera takes a photo.

Shutter speed—The amount of time that the camera's shutter is open during an exposure to allow light to reach the film.

SLR camera—A single-lens-reflex (SLR) camera has a viewfinder that allows you to look through the lens. SLRs use interchangeable lenses.

Slide film—A type of film that produces positive transparencies, commonly known as slides or "chromes," rather than negatives.

Spot meter—A type of exposure meter, built into some SLRs and point & shoot cameras, that evaluates the light reflected from a small area—a "spot"—in the center of the image as seen through the viewfinder.

Stop—The increments between each of the standard shutter speeds and between each of the standard apertures (f-stops). Changing either the shutter speed or the aperture by one stop will either double or cut in half the amount of light that will reach the film during an exposure.

Supplementary close-up lens—A filter-like accessory that screws onto the front of a lens and reduces the minimum focusing distance of the lens, thus allowing the photographer to take photos closer to subjects.

Telephoto lens—A lens with a focal length significantly longer than 50mm.

35mm film—The most common format for point & shoot and SLR cameras and film; each frame is approximately 35mm long.

Underexposure—A photo or a portion of a photo that is too dark because the film was not exposed to enough light.

Warming filter—A filter with an amber cast used to give photos a "warmer" look.

Wide-angle lens—A lens with a focal length significantly shorter than 50mm.

Zoom lens—A lens that can be adjusted to a range of different focal lengths.

About the Author

Cub Kahn is a professional nature photographer, writer and environmental educator based in the foothills of Oregon's Coast Range. He has taught outdoor photography for sixteen years, and his photos have appeared in numerous publications including *Audubon, Backpacker, National Wildlife, Sierra,* and *The New York Times.* He is the author of *Essential Skills for Nature Photography* and *The Art of Photographing Water* published by Amherst Media. Cub's photography focuses on the landscapes and ecology of mountains, rivers and coastal landscapes. His nature photography brings together his training as an environmental scientist, his love of wild landscapes, and his passion to discover and share the wonders of nature.

Index

A

Aerial photography, 61
Animals, photographing,
 see Wildlife photography
Aperture, 28–33
 changing, 29
 depth of field, 29, 30–33
 for close-up photography, 66
 f-stops, 29–33
 half-stops, 29
 relationship to shutter speed, 29–30
 selecting, 30–33
Aspect ratio, 7

B

Batteries
 cleaning, 18
 performance at low temperatures, 18
Birds, backyard, photographing, 83–85
Birds of prey, photographing, 82
Butterflies, photographing 80–82

C

Cable release, 27
 with tripod, 16
Cameras
 APS, 7
 care of, 12
 digital, 8–9
 large format, 7–8
 medium format, 7–8

Cameras (continued)
 point & shoot, 6–7
 SLR, 6–7
 35mm, 6–7
 viewfinders, 6, 7
 weight of, 8
Close-up photography
 aperture, 66
 close-up lenses, 64–65
 composition in, 41
 depth of field, 65–66
 diopters, 65
 extension tubes, 64–65
 films for, 21
 flash with, 18, 67–71
 focusing, 47, 66
 lenses for, 62
 point & shoots with, 7
 squaring up subjects, 66–67
 subjects, 72–73
 tripod use for, 66
Colors
 intensifying, 13–14, 44
 overexposure, 35
 rendition of, 19
 underexposure, 35
Composition, 37–44
 centering, avoiding, 42–43, 46
 clarifying your message, 37–38
 distractions, 39
 filling the frame, 39

Composition *(continued)*
 foregrounds, 51–52
 framing, 39, 50
 horizons, 51, 56, 57
 importance of light, 43–44
 leading lines, 41–42
 lines, 41–42, 58
 patterns, 54
 rule of thirds, 43
 simplicity, 38–39, 56
 subtractive approach, 38
 tripod, improving with, 44
 verticals, 39–40, 54, 58
Contrast
 control of, 14
 impact of film, 19
 lighting, 44

D

Depth of field
 aperture, 29, 30–33
 in close-up photography, 65–66
 focal length, 30–31
 preview, 33
 reference tables, 31
 scale, 31
Dust, danger to camera, 12

E

Electronics, frozen, 18
Enlargements, 8, 19, 21
Exposure
 action mode, 25
 aperture priority mode, 25
 auto, 6, 7, 8
 backlight compensation, 7, 35
 bracketing, 32
 compensation, 35–36, 54–55, 57–58
 control, 6
 latitude, 24
 long, 27

Exposure *(continued)*
 low light, 18, 21–23
 manual, 6, 25
 overexposure, 35
 print film, 36
 program mode, 25
 shutter priority mode, 25
 slide film, 36
 sports mode, 25
 underexposure, 35
 with point & shoots, 7
Extension tubes, 64–65

F

Film,
 APS, 7
 cost, 21, 23–24
 grain, 19, 21
 high speed, 12, 21–23
 120 format, 7–8
 print vs. slide, 23–24
 sharpness, 19, 21
 slide, 8, 19, 23–24
 speed, 19–23
 220 format, 7–8
Filters
 graduated neutral density, 14
 haze, 18
 polarizing, 18
 skylight, 18
 ultraviolet (UV), 13
 warming, 14
Flash
 built-in, 7, 17–18
 dedicated, 18
 fill-in, 18
 for close-up photography, 67–71
 power, 17–18
 separate, 18
 working distance, 18
Flowers, photographing, 72–73

Focusing
 auto, 6, 7, 8, 45–48
 close-ups, 47, 66
 distance, 7, 45, 62
 focus confirmation, 45
 focus lock, 45–46
 infinity lock, 7, 48
 manual, 48–49
 pre-focusing, 45–46
 with telephoto lenses, 49
 with zoom lenses, 49
Forests, photographing, 52
F-stops, 29–33

H
Heat, danger to camera, 12

I
Index prints, 7
Insects, photographing 80–82

L
Landscape photography
 aerials, 61
 foreground, strengthening, 51–52
 forests, 52–54
 framing the scene, 50
 horizon, placing, 51, 56, 57
 humans in, 52
 lens selection for, 51
 rivers, 58–61
 seascapes, 55–57
 snowy scenes, 54–55
 waterfalls, 58–61
 wetlands, 54
Lenses
 aperture, *see* Aperture
 built-in, 7, 11
 close-up, 64–65
 cost, 10–11
 depth of field, 30–31

Lenses (continued)
 depth of field scale, 31
 diopter, 65
 focal length, 11, 30–31, 75–77
 for landscapes, 51
 for point & shoots, 11–12
 for SLRs, 9–11
 for wildlife photography, 75–77
 interchangeable, 6, 10–11
 macro, 64–65
 protecting, 13
 quality of, 9
 speed, 29
 standard, 11
 teleconverters, 75–77
 telephoto, 6, 7, 11, 29, 51–52
 weight, 11
 wide-angle, 6, 11, 51
 zoom, 6, 7, 11–12, 29, 51, 64–65,
 75–77
Light
 backlighting, 44
 cloudy days, 44
 color, 43
 direction ,43
 flash, *see* Flash
 modifying, 71–72
 natural, 43–44
 quality, 43
 side lighting, 43–44
 sunrise, 57–58
 sunset, 57–58

M

Mammals, photographing 79–80
Meters, light
 how they work, 33
 snowy scenes, 54–55
 spot, 7, 36
 using, 33–36
Moisture, danger to camera, 12
Motion, blurred, 19, 21, 25, 27–28, 61

R

Reflections, eliminating, 18
Reflectors, 71–72
Reptiles, photographing 80–82
Rivers, photographing, 58–61

S

Saltwater, danger to camera, 12
Sand, danger to camera, 12
Scanning, 9
Seascapes, 55–57
Self-timers, 16
Shutter speed, 19, 26–28
 "B" setting, 27
 half-stops, 27
 measurement of, 26
 relationship to aperture, 29–30
 selecting, 27–28
 stops, 27
 stopping motion with, 21, 61
 water, moving, 61
Silhouettes, 44
Slides, 8, 19, 23–24, 36
Snowy scenes, photographing, 54–55
Sunrises and sunsets, 57–58

T

Time of day, 54, 57–58, 77
Tripod
 and shutter speed, 28
 composition with, 44
 cost, 15
 for close-up photography, 66
 head, 16
 height, 16
 selecting, 15–16
 weight, 15–16

W

Waterfalls, photographing, 58–61
Waterfowl, photographing, 82–83
Wetlands, photographing, 54
Wildlife photography, 74–85
 animal behavior, 74–75
 birds, backyard, 83–85
 birds of prey, 82
 depth of field, 75
 feeding animals, 78–79
 mammals, 79–80
 lens selection for, 75–77
 patience required, 78
 safety, 79
 small animals, 80–82
 teleconverters, 75–77
 time of day, 77
 waterfowl, 82–83

Other Books from
Amherst Media

Professional Secrets of Nature Photography

Judy Holmes

Learn to make top-quality images, from selecting equipment to shooting techniques for professional results. $29.95 list, 8½x11, 120p, 100 color photos, order no. 1682.

Outdoor and Survival Skills for Nature Photographers

Ralph LaPlant and Amy Sharpe

Learn all the skills you need to have a safe and productive shoot—from selecting equipment, to finding subjects, to dealing with injuries. $17.95 list, 8½x11, 80p, order no. 1678.

Composition Techniques from a Master Photographer

Ernst Wildi

Learn to evaluate subjects and compose powerful images with this beautiful, full-color book. $29.95 list, 8½x11, 128p, 100+ full-color photos, order no. 1685.

The Art and Science of Butterfly Photography

William Folsom

Learn to understand and predict butterfly behavior, when to photograph, and how to capture breathtaking images of these colorful creatures. $29.95 list, 8½x11, 120p, 100 photos, order no. 1680.

Black & White Photography for 35mm

Richard Mizdal

A complete guide to shooting and darkroom techniques! Perfect for beginning or intermediate photographers who want to improve their skills. $29.95 list, 8½x11, 128p, 100+ b&w photos, order no. 1670.

Photographing Creative Landscapes

Michael Orton

This step-by-step guide is the key to escaping from your creative rut and beginning to shoot more expressive images. $29.95 list, 8½x11, 128p, 70 photos, order no. 1714.

Macro and Close-up Photography Handbook

Stan Sholik and Ron Eggers

Get close and capture breathtaking shots of small subjects. Designed with the 35mm shooter in mind. $29.95 list, 8½x11, 120p, 80 photos, order no. 1686.

Picture-Taking for Moms & Dads

Ron Nichols

Anyone can push a button and take a picture. It takes more to create a portrait that will be treasured for years to come. With this book, moms and dads will learn how to achieve great results—with any camera! $12.95 list, 6x9, 80p, 50 photos, order no. 1717.

How to Take Great Pet Pictures

Ron Nichols

Learn what beginners need to know to take charming photos of these beloved family members—images that will be treasured forever. $14.95 list, 6x9, 80p, 40 full-color photos, order no. 1729.

Beginner's Guide to Adobe® Photoshop®

Michelle Perkins

Learn to make your images look their best and to add unique effects. Topics presented in short, easy-to-digest sections that ensure rapid success. $29.95 list, 8½x11, 128p, 150 full-color photos, order no. 1732.

The Best of Nature Photography

Jenni Bidner and Meleda Wegner

Follow in the footsteps of legendary nature photographers like Jim Zuckerman and learn to capture the drama of nature on film. $29.95 list, 8½x11, 128p, 150 full-color photos, order no. 1744.

Beginner's Guide to Digital Imaging

Rob Sheppard

Learn to select and use digital technologies that will lend excitement and provide increased control over your images. $29.95 list, 8½x11, 128p, 80 full-color photos, order no. 1738.

More Photo Books Are Available

Contact us for a FREE catalog:

AMHERST MEDIA
PO BOX 586
AMHERST, NY 14226 USA

www.AmherstMedia.com

Ordering & Sales Information:

INDIVIDUALS: If possible, purchase books from an Amherst Media retailer. Write to us for the dealer nearest you. To order direct, send a check or money order with a note listing the books you want and your shipping address. For U.S. delivery, freight charges for first book are $4.00 (add $1.00 for each additional book). For delivery to Canada/Mexico, freight charges for first book are $9.00 (add $2.50 for each additional book). For delivery to all other countries, freight charges for first book are $11.00 (add $2.50 for each additional book). Visa and MasterCard accepted. New York state residents add 8% sales tax.

DEALERS, DISTRIBUTORS & COLLEGES: Write, call or fax to place orders. For price information, contact Amherst Media or an Amherst Media sales representative. Net 30 days.

1(800)622-3278 or (716)874-4450 FAX: (716)874-4508
All prices, publication dates, and specifications are subject to change without notice.
Prices are in U.S. dollars. Payment in U.S. funds only.